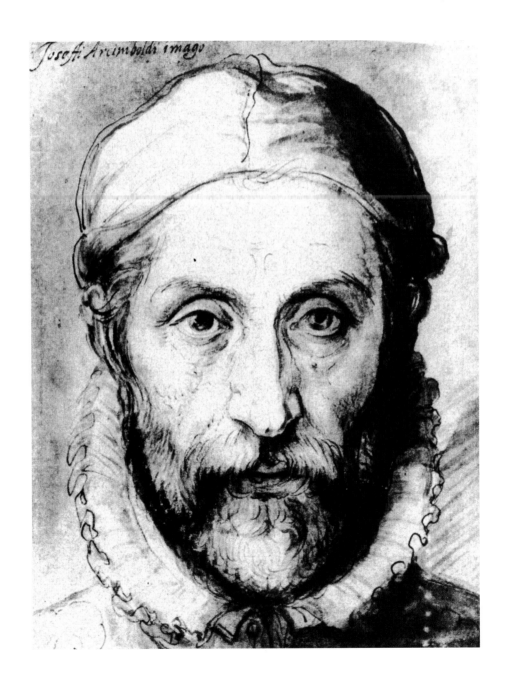

Werner Kriegeskorte

GIUSEPPE ARCIMBOLDO

1527–1593

TASCHEN

KÖLN LONDON MADRID NEW YORK PARIS TOKYO

FRONT COVER:
Detail from: **Summer,** 1573
Oil on canvas, 76 x 64 cm
Musée National du Louvre, Paris
Photo: AKG Berlin

ILLUSTRATION PAGE 2 AND BACK COVER:
Self-Portrait, c. 1575
Blue pen-and-wash drawing,
23 x 15.7 cm
Národni Galerie, Prague

© 2000 Benedikt Taschen Verlag GmbH
Hohenzollernring 53, D–50672 Köln
www.taschen.com
English translation: Hugh Beyer
Cover design: Claudia Frey, Angelika Taschen, Cologne

Printed in Germany
ISBN 3–8228–5993–1

Contents

6
Life and work of Arcimboldo

28
Arcimboldo's Pictures

44
Arcimboldo's Vertumnus

62
Arcimboldo as a Scientist

70
Arcimboldo's Drawings

77
Chronology

79
Bibliography

Life and work of Arcimboldo

There is an entry in the register of deaths at the *Magistro della Sanità* of Milan which states that the painter Giuseppe Arcimboldo died on 11 July 1593, at the age of about 66, with "retention of urine and kidney stones" as the cause of his death. It also mentions that he had not died from the plague. Arcimboldo was probably born in Milan in 1527, the same year in which Rome was conquered and plundered by Charles the Fifth's mercenaries.

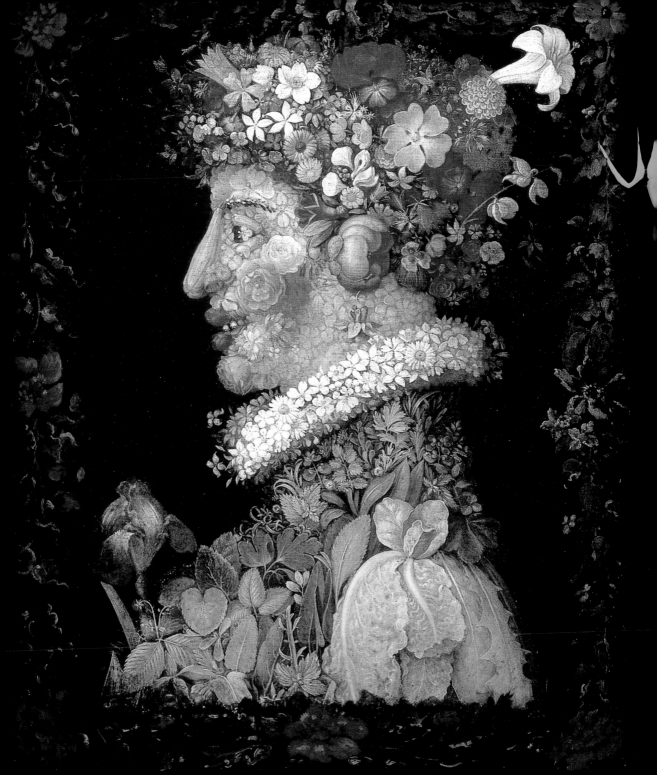

Spring, 1573
Oil on canvas, 76 × 64 cm
Musée National du Louvre, Paris

Arcimboldo's **Spring** is completely fra-
med by garlands which were painted in
a style distinctly different from that of the
figure. A. Pieyre de Mandiargues was
probably right when he wrote that the
garlands must have been added later.
When we look at the painting from a
distance, we notice that the face is that of
a young woman with a gentle smile. A
close look, however, reveals that her skin,
hair and clothes are only an illusion and
that the woman is in fact composed of
the petals and stalks of spring flowers,
which are rendered in minute detail. Her
skin consists of blossoms ranging from
white to pink, her hair is made up of a
magnificent array of colourful flowers,
and her dress is a collection of green
plants. Her nose is the bud of a lily, her
ear a tulip, and her eye is a couple of
black nightshades and their blossom.
White flowers are arranged to form a ruff,
which separates face from dress.

Summer, 1573
Oil on canvas, 76 × 64 cm
Musée National du Louvre, Paris
Signed and dated on the collar and the
shoulder: Giuseppe Arcimboldo. F. 1573

Like **Spring,** this picture belongs to the
complete series of the Four Seasons
which is now in the Musée National du
Louvre in Paris. What is said about the
garlands around the first picture also
applies to this one.
Both **Summer** and **Spring** are human
heads in profile. **Summer** consists entirely
of different kinds of summer fruit and
vegetables. The glowing colours of the
head stand out in bold relief against the
dark background.

On the broad, stiff collar he has delicately
woven the words "Giuseppe Arcimboldo
– F." The F stands for **fecit** ("he has done
it"). This is the painter's way of authentic-
ating his work of art. On the shoulder
there is the date of the painting: 1573.

His father, who worked as a painter for Milan Cathedral,
was called Biagio Arcimboldo or Arcimboldi. It is still
uncertain which version is the correct one, because Giuseppe
himself used to write it differently. Sometimes he would sign
his name as Arcimboldo, then again Arcimboldi or
Arcimboldus. Sometimes he would put Giuseppe, then
Josephus, Joseph or Josepho. I have decided to use the name
Arcimboldo, which has been common in France and
everywhere else, though not in Italy.

Like all Italian names with the ending *-baldo* or *-boldo,*
Arcimboldo is Southern Germanic in origin. The history of
the Arcimboldo family was recorded by Father F. Paolo
Morigia, who faithfully wrote down everything the artist told
him. And according to Father Morigia it goes back as far
as Charlemagne, in whose services there was said to have
been a certain Southern German nobleman by the name of
Gaitfrid Arcimboldi. Of his sixteen children three were said
to have excelled so much that they were also ennobled. One
of these three subsequently emigrated to Italy, where he
established the Italian line of the Arcimboldi family. This story
is undoubtedly a mixture of history and legend, but the
following words of Morigia's seem to be more securely
grounded in facts: "Everything I have been saying about the
Arcimboldis comes from Mr. Giuseppe Arcimboldi, a trust-
worthy gentleman with an impeccable lifestyle, who has
served two German Emperors (which will be expounded
further), and he has copied these details about the ancestry
and origins of the Arcimboldi family from an ancient
parchment in the German language which was read to him
by the physician of the Emperor Maximilian, and he declares
furthermore that he has visited two places which are called
Arcimboldi. He also says that in the city of Augsburg, near its
biggest church, there is a big cemetery with a large chapel, and
on entering through the gate one can see an ancient
tombstone of red marble bearing the coat of arms of the
Arcimboldi family with its characteristic letters. Likewise he
firmly asserts that, in the city of Regensburg in the large
cathedral churchyard, he saw a big and very ancient tomb with
the coat of arms of the Arcimboldis and its typical letters
etched into it, and that there are many Arcimboldis all over
Germany."

Thus spoke Morigia. And it is indeed true that
Arcimboldo was commissioned by the Emperor Rudolph II to
make a journey to Kempten, so it is quite plausible that he
went via Augsburg and Regensburg.

In his *Nobilità di Milano* Father Morigia gives a very
detailed account of the history of the noble family of
Arcimboldo, and so we learn that Guido Antonio
Arcimboldo, Giuseppe's great-great-grandfather, was elected
Archbishop of Milan as a widower in 1489, thus becoming the

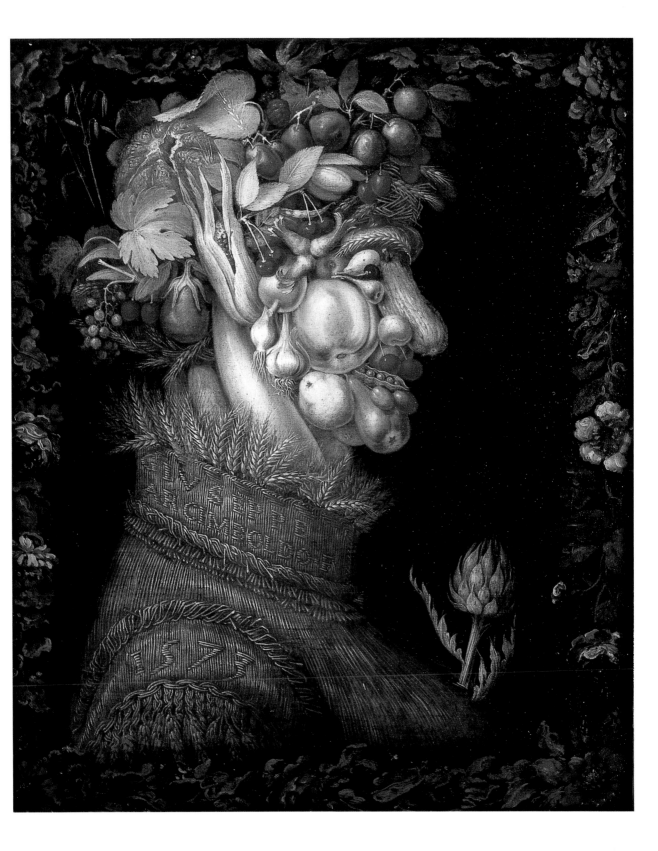

Autumn, 1573
Oil on canvas, 76 × 64 cm
Musée National du Louvre, Paris

The notes on the previous two paintings also apply to **Autumn,** which was painted in the same year. A broken old tub is held together by some wicker branches in a somewhat makeshift arrangement, and a head protrudes from it. It is the head of a rather rough sort of fellow, and is made up of autumn produce. His bulbous nose is a juicy pear, his healthy-looking cheek is a ripe apple, his chin is a pomegranate and his ear is a large mushroom, which could be a russula. It seems appropriate that the ear-ring should be an over-ripe, burst fig. His head is crowned with red and white grapes, reddish vine-leaves and a gigantic squash, thus reminding us of Arcimboldo's earlier depictions of Bacchus. The sumptuousness of the fruit is an indication of the fertility of autumn, and the sharp tongue which comes through the prickly lips seems to signal Autumn's joyful anticipation of culinary delights.

successor of his deceased brother Giovanni. Guido Antonio's son Filippo was the father of Pace, Giuseppe's grandfather. Biagio, Giuseppe's father, was Pace's illegitimate son. Guido Antonio's brother Giovanni, who died in 1489, was the grandfather of Gianangelo Arcimboldo, who was born in 1487 and held the position of Archbishop of Milan from 1550 until his death in 1555. This great-uncle must have been quite influential in Giuseppe's life when he was young. He introduced him to artists, scholars, writers and important humanists who used to come to his house. These contacts probably helped to lay the foundation for that turning point which was to take place in Arcimboldo's art and which was regarded by many as somewhat eccentric. It is likely that Giuseppe also knew the German artists who were working on Milan Cathedral or who were producing tapestries for the Medicis.

Apart from that we know very little about young Giuseppe's development. However, considering that he became quite a famous and erudite artist, we have reason to assume that the foundation must have been laid in his youth. One of Arcimboldo's early contacts is mentioned by Benno Geiger. Giuseppe's father was a friend of the painter Bernardino Luini, a pupil of Leonardo da Vinci's. However, Giuseppe had no direct relationship with either of the two: Leonardo had left Milan in 1516 and then gone to France, where he died in 1519; and Bernardino Luini died as early as 1532, when Arcimboldo was only five years old. Nevertheless, a link with Leonardo via Luini did exist. When Leonardo left Milan, he handed his notes and sketch books to Luini, and it was through Luini's son that Giuseppe saw them. We can imagine that a lot of it must have left a deep impression on the young artist. Because of the expulsion of Duke Ludovico (il Moro) from Milan, as well as a plague epidemic at the beginning of the 16th century, Milan had lost its leading position in the world of art. However, there were still links with other cities and artists in the whole of Italy, as well as Germany, the Netherlands and France. We can safely assume that Arcimboldo cultivated his contacts not only with painters, but also with philosophers and other scholars.

In 1549, at the age of 22, Giuseppe Arcimboldo made his debut as an artist. The records of Milan Cathedral tell us that, together with his father, he was paid for designing several stained glass windows. In 1551 he painted five coats of arms for Ferdinand of Bohemia; the duke was passing through Milan and was probably told about Arcimboldo. This was before he became Emperor Ferdinand I. It is possible that Arcimboldo was already more famous than we are aware. This conclusion is in fact justified when we read an account by Paolo Morigia, a friend and contemporary of Arcimboldo's. When the painter went to Prague in 1562, Paolo Morigia assessed his fame in

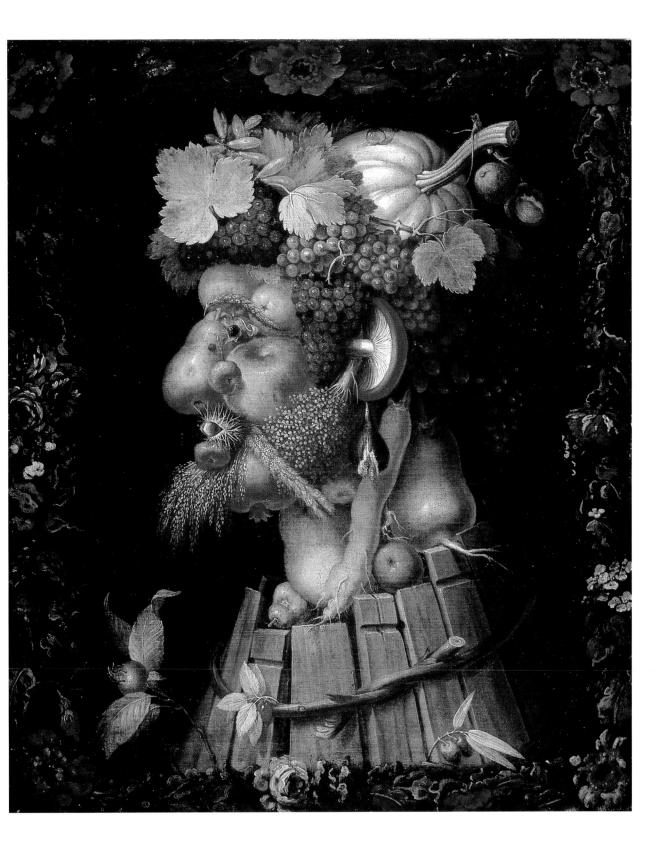

Winter, 1573
Oil on canvas, 76 × 64 cm
Musée National du Louvre, Paris

Winter is the final picture in the series of the Four Seasons which Arcimboldo painted in 1573. Although only **Summer** was signed by the artist, there are so many similarities between the pictures that there can be no doubt about the authenticity of the other three paintings. Winter is depicted as an ancient tree stump, which has almost died, with cracked bark, partly detached from the tree. It is easy to make out a pathetic old man whose nose is peeling and whose swollen, toothless mouth – a mushroom – sits crookedly on a chin full of warts. His face is covered with a stubbly beard and is full of scars and scabs. His eye seems to be hiding in a deep crack in the bark, and what we recognize as an ear is nothing but the remainder of a broken-off branch. A thick straw mat protects the old man from the cold.

However, Arcimboldo does not see winter just as the cold season; his picture also contains an element of comfort. Hanging from a broken branch there are an orange and a lemon: with their glowing colours they introduce a glimmer of sunshine and warmth into the cheerless atmosphere. The green ivy growing from the back of the old man's head, as well as the tangle of branches resembling a crown, reinforce the feeling of hope that winter will not last for ever. If we take a closer look at the straw mat that envelops Winter like a cloak, we can make out a coat of arms. Arcimboldo often received commissions from the Emperor to paint the Four Seasons, and this was how he sometimes indicated the recipient of the picture.

these words: "This is a painter with a rare talent, who is also extremely knowledgeable in other disciplines; and having proved his worth both as an artist and as a bizarre painter, not only in his own country but also abroad, he has been given the highest praise, in that word of his fame has reached the Emperor's court in Germany."

From 1551 onwards only Giuseppe is mentioned in the cathedral documents, probably because that was the time when his father died. Until 1558 there were regular entries about a whole series of cathedral assignments. But the only design which has been preserved and identified is that of a number of stained glass windows to illustrate the history of St. Catherine of Alexandria in 48 parts. This seems to be all that is left of the work of the two Arcimboldos at Milan Cathedral. Geiger points out that "the stories concerning St. Catherine, which were started by both painters together and finished by the son, did not go beyond the confines of the typical style of the time, the style in which the lives of saints were usually depicted. These and other stained glass windows clearly show the influence of Gaudenzio Ferrari more than anybody else's." But Geiger also believes that there are "Arcimboldesque" elements in some of the windows, so maybe there are also some in at least one of the examples shown in this book. Also, it is quite possible that among the large number of unidentified stained glass windows there are quite a few which were designed by Arcimboldo. After all, the number of designs for which he was paid far exceeds that of his St. Catherine windows. According to Geiger, these windows contain some clear elements of the style he was to adopt later.

In 1559, Arcimboldo is mentioned in the documents of Milan Cathedral for the last time. The clue to this is an entry in the account book of Como Cathedral.

1558: *Lire 159.19 to Master Giuseppe Arcimboldo, painter from Milan, for the design and model of the Celone (Gobelin tapestry), as mentioned in the account book of that year.*

So this first Gobelin tapestry was undoubtedly designed by Arcimboldo. And there is no reason why we should doubt the authenticity of seven others. They are all equal in size and colour scheme. A simple comparison confirms their similarity: "The sumptuously ornamental paintings full of fruit and blossom, flower bunches and garlands, angels and little cherubs, as well as an abundance of scroll-shaped ornaments which do not leave space for anything else" – all these elements show clearly the hand of one single artist. Also, they show even more clearly than his stained glass windows what kind of style he was to adopt later. The ornamental sumptuousness of his pictures as well as his depiction of various scenes can be called "Arcimboldesque". Geiger

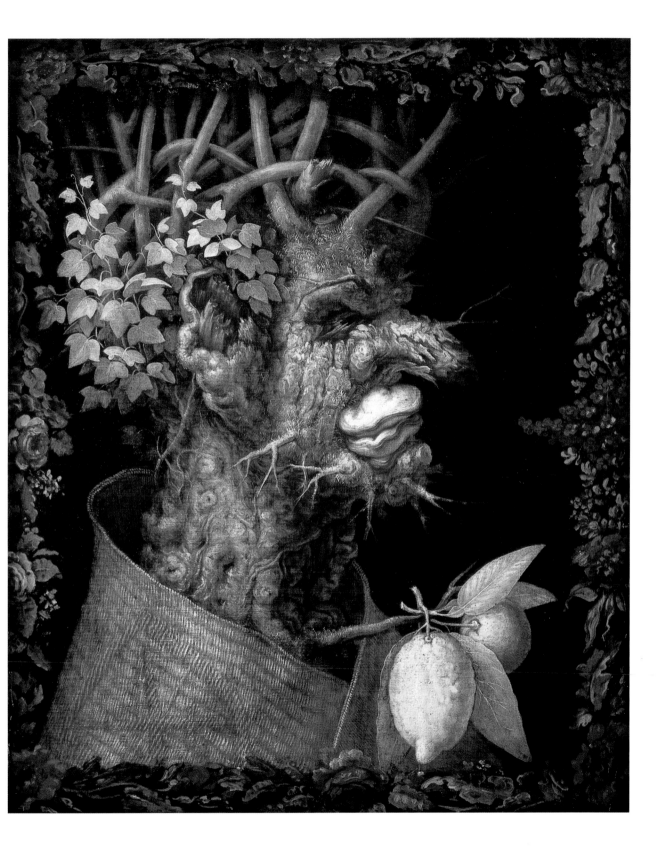

 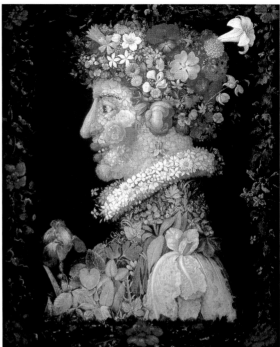

The order of the **Seasons** is full of symbolical symmetry. There are always two matching heads in profile, one of them facing left, the other right and expressing a special relationship between the seasons they symbolize.

believes that Arcimboldo might have been influenced by the two Flemings Johannes and Ludwig Karcher, who used to make the Gobelin tapestries to his designs, or, alternatively, that "his Germanic heritage was aroused" in the artist.

In 1562 Giuseppe gave in to the repeated requests of Emperor Ferdinand I and went to Prague. Benno Geiger's source study confirms that Arcimboldo must have continued to be famous even after the Emperor had asked him to be the court artist.

To give an idea of the relationship between Arcimboldo and Ferdinand I as well as his successors, the Emperors Maximilian II and Rudolph II, I shall quote Morigia again, who says in his *Historia dell'Antichità di Milano* of 1592: "In 1562 he (Arcimboldo) left his country and joined the Emperor's court, where he was liked and treated well (by the Emperor) and received with great kindness, and the Emperor gave him a good salary worthy of his merits and also showed his affection in many other ways. And so our Arcimboldo lived a very fulfilling and honourable life at the Imperial court, not only for him (Ferdinand), but also the entire court, not only with his paintings, but also many other works of art and pieces of woodwork for occasions such as tournaments, games, weddings, coronations, and especially when Archduke Charles of Austria took a wife. This noble and inspired man

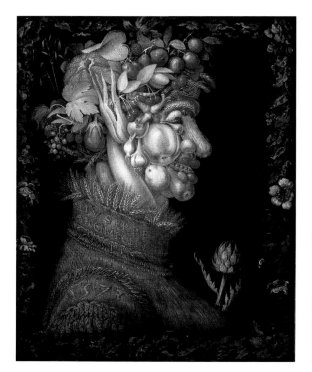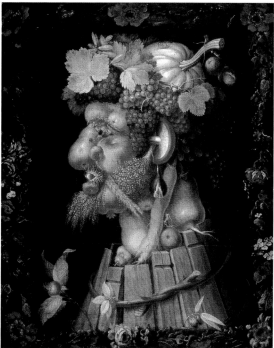

Summer and **Autumn**, 1573
Oil on canvas, each 76 × 64 cm
Musée National du Louvre, Paris

fashioned a great number of rare and delicate works of art which caused considerable amazement among all the illustrious noblemen who used to congregate there, and his lord and master (Ferdinand) was very pleased with him. It is also worth mentioning that when Maximilian succeeded his father on the Imperial throne, Arcimboldo was never refused permission to see the Emperor at any hour of the day, for he was counted among those who were in particular favour with the Emperor, and indeed the whole of the Austrian court befriended him and loved him for his art as well as his impeccable disposition. When Maximilian died, he was succeeded by his son Rudolph, who extended the same favour and love to Arcimboldo as his father had done. When, after twenty-six years of service to these two great monarchs and to the whole House of Austria, this noble and honourable Giuseppe asked the Emperor several times over a period of two years if he might very kindly be granted leave to return to his home country in order to enjoy his old age there, he was finally granted this favour, albeit very reluctantly, for His Imperial Majesty had become so fond of him that he was loath to deprive himself of his presence."

From 1562 onwards we have a clearer picture of Giuseppe Arcimboldo's life, thanks especially to the entries in the *Archiv für Kunde österreichischer Geschichtsquellen*

Air, undated
Oil on canvas, 74.5 × 56 cm
Private collection, Basle

Air, like the Four Seasons and the other three elements, has been depicted in the form of a human head in profile. To express his ideas on the nature of air, Arcimboldo has populated this picture with a large number of birds. Most of them have only their heads visible and can hardly be identified, whereas others can be recognized immediately. The goose, for example, is quite easy to make out, and together with the tail feathers of a rooster gives a vague impression of an ear. The turkey with its swelled breast is the nose, and a pheasant, hiding partly under the wings of the rooster, provides a goatee beard with his tail feathers, thus decorating the chin of the figure.
The little bird whose eye serves as the pupil of the human head remains a mystery, however, while the upper and lower eye-lid of the head is formed by the open beak of a duck.
Arcimboldo's Four Elements contain some obvious references to the House of Hapsburg, such as the peacock and the eagle, which are both symbols of the dynasty.

("Archive of Austrian Historical Sources") and the *Urkunden und Regesten aus dem Jahrbuch des Allerhöchsten Kaiserhauses* ("Documents and Records from the Almanac of the Most High Imperial House").

During the two years when Arcimboldo served Ferdinand I he painted several portraits of the Imperial family as well as the first series of his Four Seasons. Two of these, *Summer* and *Winter,* are in the Kunsthistorisches Museum in Vienna. *Spring* can be seen in the Real Academia de Bellas Artes de San Fernando in Madrid, and *Autumn* has been lost.

The artistic concept of these pictures of 1563 was unique and laid the foundation of Arcimboldo's success as a painter. The documents of the time bear witness to the fact that monarchs and his contemporaries in general were quite enthusiastic about his art. We do not know why there was this sudden turning point. As I pointed out above, Geiger believes that there were elements of it in his earlier paintings. And during his time at the Imperial court, these tendencies were undoubtedly reinforced by his acquaintance with pictures by Bosch, Brueghel, Cranach, Grien and Altdorfer.

When Ferdinand I died in 1564 and was succeeded by Emperor Maximilian II, Arcimboldo continued as his court artist, with a monthly salary of twenty guilders. On special occasions the Emperor sometimes gave him a special supplement. It could be that he particularly liked a certain painting or that he gave him money for a special journey, such as a trip to Italy in 1566, which he sponsored with a hundred guilders.

There is little doubt that a large number of pictures must have been painted between 1564 and 1576, but only very few of them are known to us. We do know that in 1566 Arcimboldo painted the Four Elements. Two of them, *Water* and *Fire,* are now in the Kunsthistorisches Museum in Vienna, whereas the other two, *Earth* and *Air,* have still not been located. Research has shown that Arcimboldo also painted the following pictures during the reign of Maximilian II: *The Lawyer* (1566), another series of the Four Seasons in 1572, an *Autumn* and a *Winter,* two series of Four Seasons in 1573, and in 1574 *The Cook* and *The Wine Steward.* The last two pictures are lost.

But apart from painting, Arcimboldo also had other duties at the Imperial court. As he was a man of many talents, he also served the Emperor as an architect, stage designer, engineer, water engineer and art specialist. Because of his extensive knowledge he was able to exert his influence on Maximilian II. According to Lomazzo, Maximilian valued Arcimboldo's views so much that he not only listened to his judgement but also adapted his own taste to that of the artist. With Arcimboldo's help he extended his art and curio

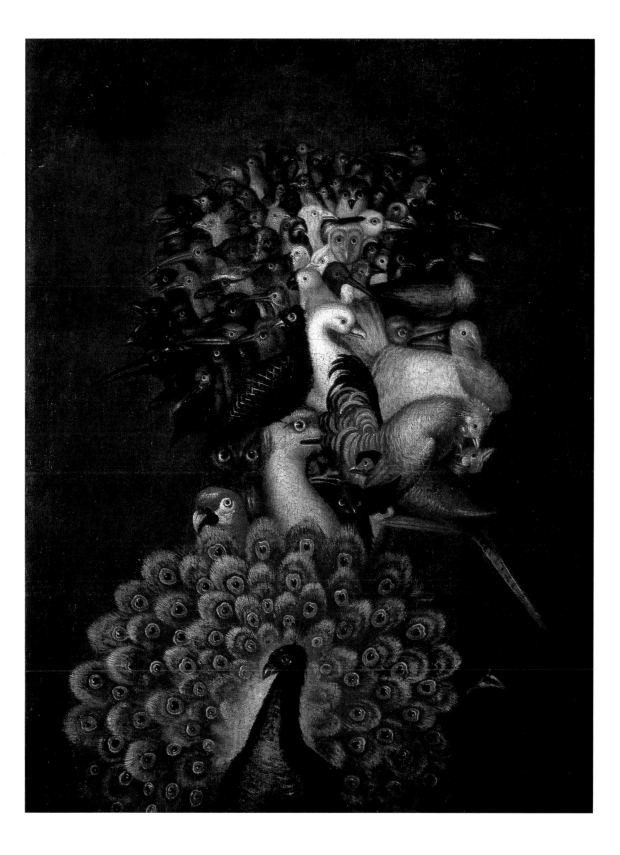

Fire, 1566
Oil on limewood, 66.5 × 51 cm
Kunsthistorisches Museum, Vienna

There is an inscription in the lower right-hand corner of the gunbarrel which reads: "Josephus Arcimboldus Menensis. F." The date and the title are on the other side of the painting: 1566 Ignis".
In this allegory Arcimboldo depicted several different types of fire, ranging from the small light of an oil-lamp or a candle to the tremendous power of cannons and guns. A flame can be kindled by striking the two pieces of steel (the nose and ear) against the flint which decorates the Golden Fleece. This will light the little oil-lamp (the chin of the figure), the bundle of spills (the moustache), the rolled-up taper candle (the forehead complete with wrinkles) and finally the pile of firewood, whose flames surround the head like a crown. There is hardly any other work of Arcimboldo's which is more explicit in its references to the Hapsburgs. The neck is separated from the body by the chain of the Golden Fleece, which was one of the most important orders of the time. Duke Philip of Burgundy gave it to the Hapsburgs on the day of his wedding in 1429. Like many others, he became one of the Hapsburgs through marriage. What is even more significant is the presence of the double eagle, the symbol of the Holy Roman Empire of which the Hapsburgs were emperors at the time of Arcimboldo. Finally there are the gun and the cannons. These may well have served the purpose of emphasizing the great military power of the Hapsburg rulers, then at war with Turkey.

cabinets, thus creating the nucleus of a museum. Later they became Rudolph II's famous Art and Wonder Chambers, which will be mentioned in more detail later. It was customary among Renaissance monarchs to hold tournaments and feasts. These were always occasions of enormous pomp at the European courts. Everyone who had a high rank or a title came to these festivities: the aristocracy, church dignitaries, academics, artists and other ladies and gentlemen of high social standing. The monarch was always at the centre of the feast. He was the hero and the victor. For this reason, a tournament and a triumphal entry were always part of the show. The hero was always victorious in a tournament and returned home in a triumphal procession. The characters who took part were taken from ancient history or mythology. There were also references to the political conditions of the time, with the intention of glorifying the monarch and strengthening his political power. The common people were always thrilled by such a spectacle, which served its purpose of making them believe that everything was alright with their world and of diverting their attention from their misery.

Arcimboldo became the most prominent organizer of such festivities. The imagination he showed in designing new costumes, inventing new forms of entertainment, bizarre figures and grotesque masques was simply inexhaustible. One of his festive processions included horses disguised as dragons and a real elephant.

As Andreas Beyer points out, the sixteenth century saw a considerable increase in tournaments and festivals under the influence of classical humanism. "Florence, which was the centre of the philosophical revival, also became the most significant focal point for festive ceremonies." For the House of Hapsburg these festivities were of particular importance, because the area over which they ruled covered a large number of different nationalities, and such ceremonies gave the Emperor an opportunity to demonstrate the political power of his dynasty. The games usually consisted of three parts. First, there was the *joust* or *tilting,* in which two knights on horseback, separated by a fence, attempted to throw each other from their saddles with lances; then there was the *free tournament,* where the knights had to engage in hand-to-hand combat; and finally the so-called *foot fight,* where they had to attack each other with different kinds of weapons across a fence.

These three disciplines went back to mediaeval types of combat which were specially cultivated by the Imperial troops and demonstrated by them. As fewer and fewer knights were actually involved in real wars, these tournaments gradually took on the function of spectacles designed to lull both the Emperor and the guests into thinking that the House of Hapsburg did not have any political problems.

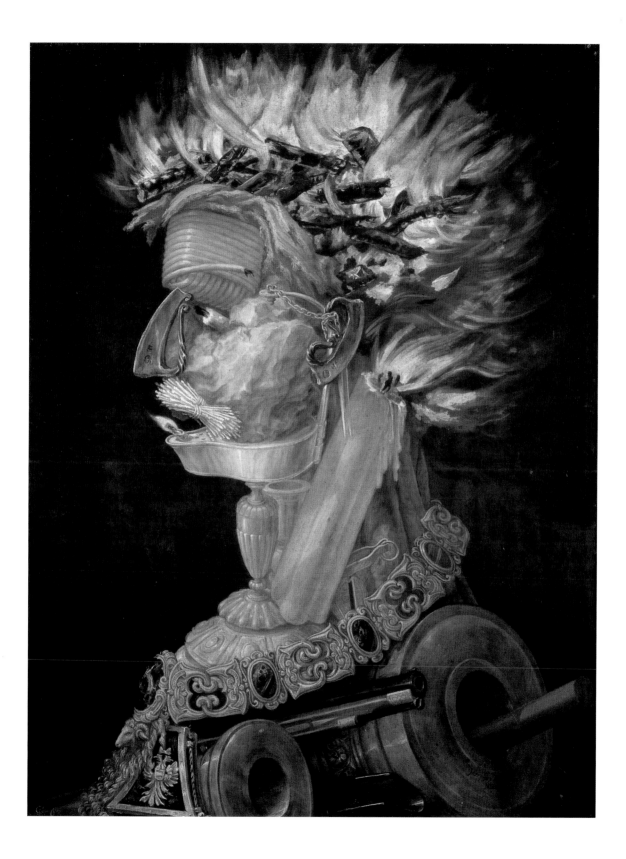

Earth, ca. 1570
Oil on wood, 70.2 × 48.7 cm
Private collection, Vienna

Benno Geiger thought that this painting depicted a hunter. Nowadays, however, it is generally acknowledged to be an allegory of **Earth.** Comanini's Figino describes this picture so vividly that is seems worth quoting the passage from Geiger's book: "The forehead contains all these animals: an Indian gazelle, a fallow doe, a leopard, a dog, a fallow buck, a red deer, and the 'big animal'. The ibex, an animal which lives in the Tyrolean mountains, has been inserted in the back of the neck, together with the rhinoceros, the mule, the monkey, the bear and the wild boar. Above the forehead are the camel, the lion and the horse. And the nice thing is that all the animals with antlers have arranged their weapons around the forehead, thus forming a king's crown: that was an amazingly clever idea, and it decorates the head very nicely, too. The area behind the cheek (the head being in profile) is formed by an elephant whose ear is large enough to be the ear of the whole figure. A donkey underneath the elephant fills out the lower jaw. For the front portion of the cheek a wolf was forced to render its service, its mouth wide open and about to snap at a mouse: its open mouth is the eye, and the mouse the pupil of the eye. The tail and the leg of the mouse form a moustache just above the upper lip. On the forehead, sitting among the other animals, there is a fox with its tail curled up, which forms the eyebrow. There is a hare on the wolf's shoulder, forming the nose, and a cat's head which is the upper lip. Instead of a chin there is a tiger, held up by the elephant's trunk. The trunk is rolled up and forms the lower lip of the figure's mouth. A lizard can be seen coming out of the open mouth. The curvature of the entire neck is formed by a recumbent ox, together with a fawn."

Although quite a few tournaments and festivals took place under Maximilian II, we only have documentary evidence for two occasions on which Arcimboldo participated as an organizer: the wedding feast of 1571 and the coronation of Rudolph as King of Hungary in 1572. On the other hand, Arcimboldo had painted several pictures for Maximilian II by the time the Emperor died in 1576. This can be seen in the following document:

The *Records from the Almanac of the Most High Imperial House* has the following entry for 28 July, 1574: *Joseph Arcimboldo, Artist and Painter to the Roman Imperial Court, hath received 65 Rhenish Guilders for sundry work and painting which he hath wrought for the Elector of Saxony at the behest of Emperor Maximilian II.*

However, most of his pictures seem to have been lost. In 1575 Arcimboldo made several paintings for the private chambers of the Emperor and was paid a commission of 75 thalers. In the same year his illegitimate son Benedict was given official recognition by Maximilian II. And in 1576, Arcimboldo was paid 200 guilders as a special and final gift from the Emperor. We do not know of any other works.

Like his two predecessors, Emperor Rudolph II also took Arcimboldo into his service. The eleven years which the artist spent with Rudolph II were probably the peak of his career. The Emperor was extremely fond of Arcimboldo and showed great appreciation for him. A peculiar mixture of irrational and scientific thought prevailed at Rudolph's court and was somehow reflected in Arcimboldo's pictures.

Rudolph II was an eccentric. Weak, depressive and introverted, he preferred to avoid problems. He was not a warlike character, but always tried to find a compromise between the feuding Catholics and Protestants. He loved the fine arts, especially painting and sculpture, and took an interest in every academic discipline. Many scholars came to his court, including Tycho de Brahe and Kepler. There were astrologers who studied the course of the stars, alchemists who tried to produce gold, and others who attempted to prove that a circle could be reduced to a square or to construct a machine that was continually in motion, a so-called *perpetuum mobile*. His museum contained the works of famous painters, and artists from all over Europe used to work for him.

All this meant that Prague had now become a major European cultural centre. But, Rudolph II's interest lay mainly in his Art and Wonder Chambers. It contained everything that was regarded as exotic at that time, all sorts of unusual objects and animals. Benno Geiger gives some examples in his book on Arcimboldo: stuffed birds (from the world as it was known then), gigantic mussels, sword- and sawfish, precious stones, demons imprisoned in blocks of glass, mummies, objects from the newly discovered continent of America, precious things

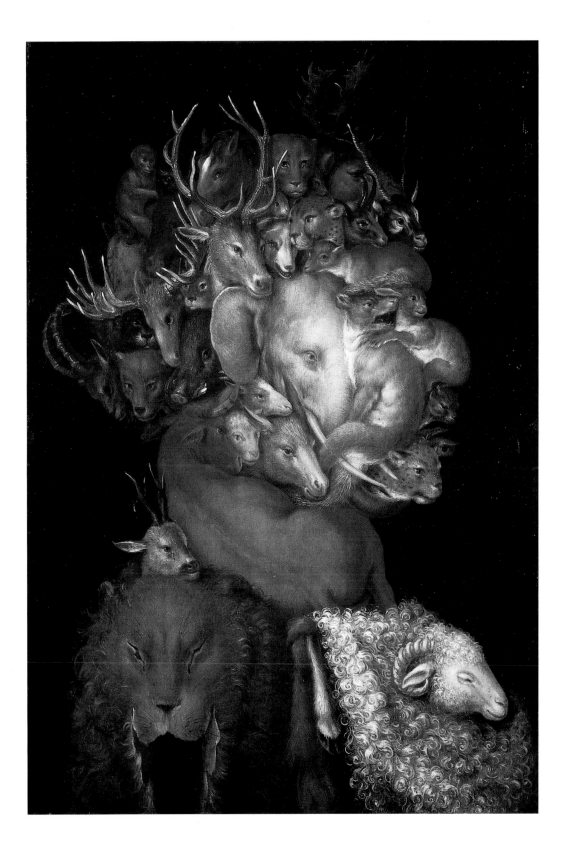

Water, 1566
Oil on limewood, 67 × 52 cm
Kunsthistorisches Museum, Vienna
Title on the reverse: Aqua

It is impossible to list all the aquatic animals that make up this head, which is an allegory of the element water. The upper part of the body appears to be formed by a coat of arms consisting of a giant crab (the breastplate), a turtle and a large mussel (the shoulder-piece) to which an octopus has attached itself with its tentacles. The neck is decorated by a pearl necklace. The cheek is a ray, and an oddly shaped pearl decorates the mussel-like ear. A squill, another member of the crab family, takes the place of the eyebrows, and the mouth is formed by that of a shark, wide agape and with sharp teeth. The top part of the head is rounded off by some kind of crown, which seems to include one or two whales, two spout fish, a walrus, a young seal, a sea horse and, somewhat hidden from view, the arms of a starfish. The impression of a crown is re-inforced by the presence of long spikes coming out of a fish's spine and crown-shaped coral next to the spout fish.

As in the other pictures, the individual animals are painted extremely realistic-ally, though without regard to their respective sizes. The impression of chaos and confusion is only superficial; it does not take long to discern the apparent harmony which underlies this host of very diverse animals, some of which are indeed enemies of one another. Their peacefulness, too, is deceptive.

The crown-like formation of animals, the harmony among them and the presence of the pearl necklace make this depiction of the element water a panegyric in honour of Maximilian. There are a number of paintings in which the artist depicts the Emperor as the lord and master of the elements and the seasons. It is only because of his benevolent rule that they and the people can live in peace and harmony.

from India and a whole zoo of exotic animals. Everywhere the Emperor had his agents whose job it was to search for the extraordinary. And we know from two sources that Arcimboldo travelled to a place called Kempten in Southern Germany, where he bought a number of objets d'art, as well as exotic birds and animals.

There had in fact been Art and Wonder Chambers for a long time. Maximilian II and Rudolph II kept extending them, and they provided exactly the right environment for Arcimboldo to thrive as an artist. It was in these chambers that he studied every detail of the animals and plants which he used for his paintings. (Incidentally, Rudolph II was a great gardening enthusiast.) All we know about Arcimboldo's activities as an artist at the Imperial court is that he painted The Four Seasons twice in 1577, that he dedicated a red leather folio containing 150 pen-and-ink drawings to the Emperor in 1585, and that he organized a number of festive processions and tournaments in the same year. We have no knowledge of any further pictures which he might have painted at the court in Prague after 1585.

Documents tell us that, in 1580, Rudolph II reconfirmed the aristocratic status of the Arcimboldo family and that he granted the artist the privilege of upgrading his coat of arms.

In 1587, after eleven years of service and a number of urgent requests, Arcimboldo finally received permission from Rudolph II to return to his native Milan. For his "long, faithful and conscientious service" he was rewarded with 1500 Rhenish guilders. And so he went back in the same year, but honoured the Emperor's request to continue working for him even though he was no longer in his service. In 1591 he painted two of his most famous pictures, *Flora the Nymph* and *Vertumnus,* which he sent to Prague. There are two versions of *Flora,* and the first one has probably been lost, but – according to Mandiargues – the second one is no worse than the first. Rudolph II must have been delighted with these paintings, because he awarded Arcimboldo one of his highest orders in 1592.

A year later, on 11 July 1593, Giuseppe Arcimboldo died.

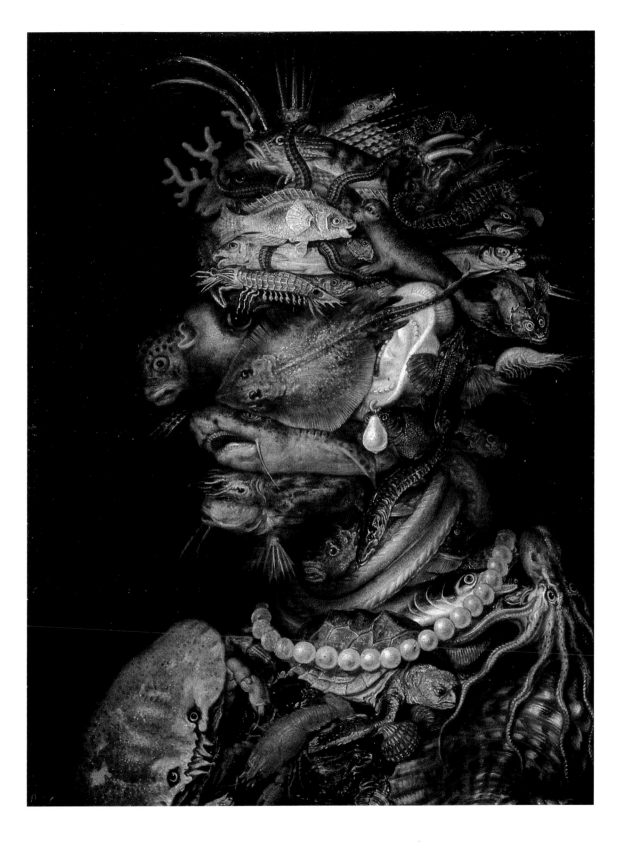

Air, undated
Oil on canvas, 74.5 × 56 cm
Private collection, Basle

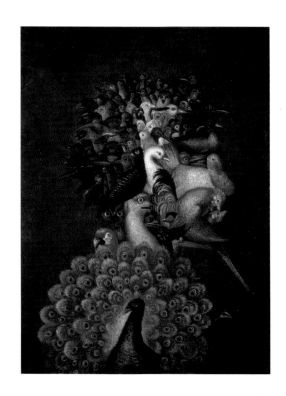

*The order of the Seasons is full
of symbolical symmetry. There are
always two matching heads in
profile, one of them facing left, the
other right and expressing a special
relationship between the seasons
they symbolize.*

*There is an abundance of
allegorical and symbolical allusions
which Arcimboldo, as it were, wrote
into his paintings and series of
paintings. His series of Elements
and Seasons share several features,
including the number four, and*

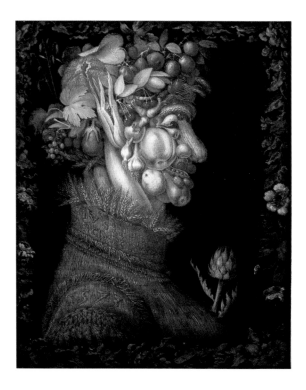

*Arcimboldo's colleague Fonteo
revealed some further
correspondences in a poem.*

*Fonteo sees the connection
between the Elements and the
Seasons partly in terms of common
features or pairs of features – cold/
warm and wet/dry – which can be
combined in four different ways so
that the following correspondences
can be established: "Summer is hot
and dry, like Fire. Winter is cold and
wet, like Water. Air and Spring are*

Summer, 1573
Oil on canvas, 76 × 64 cm
Musée National du Louvre, Paris

Spring, 1573
Oil on canvas, 76 × 64 cm
Musée National du Louvre, Paris

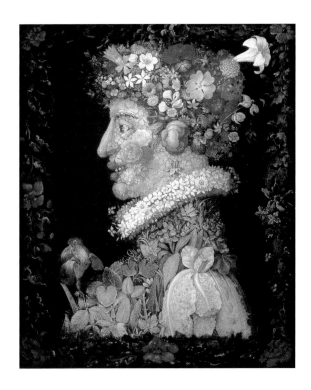

both hot and wet, and Autumn and
the Earth are cold and dry."
 Fonteo's comparison of
Arcimboldo's Elements and Seasons
is not limited to the features hot/
cold and dry/wet. The following
interpretation is based on the world
of the ancient gods and the
Renaissance understanding of
nature:
Proserpina, the goddess of winter, is
a close friend of the god of water,
Neptune, and so Winter and Water
belong together. The Air of Spring

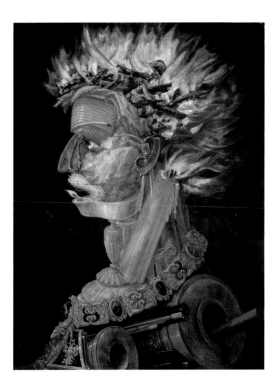

shows up the glowing colours of
flowers in blossom. Summer and
Fire both share a common star as
their point of reference – the sun,
while Earth and Autumn share the
moon.
 The correspondences between
Arcimboldo's heads in profile –
Autumn and Earth, Water and
Winter – suggest that they can be
interpreted as dialogues between the
Elements and the Seasons. These
dialogues, according to Fonteo, serve
to glorify the Hapsburg Emperor.

Fire, 1566
Oil on wood, 66.5 × 51 cm
Kunsthistorisches Museum, Vienna

Earth, around 1570
Oil on wood, 70.2 × 48.7 cm
Private collection, Vienna

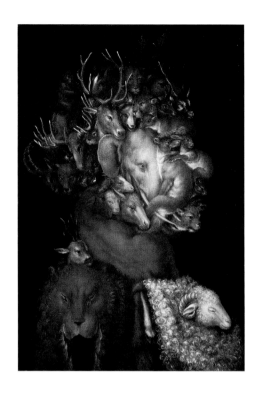

The two series of the Seasons and the Elements were topics which Arcimboldo frequently painted at the Emperor's request. This certainly seems to confirm Fonteo's interpretation of Arcimboldo's art as something that was meant to glorify the Emperor. The Hapsburg rulers apparently turned their enthusiasm for his work to good use and presented Arcimboldo's pictures as gifts to various relatives and dignitaries, so that his art served partly – or even mainly – as an

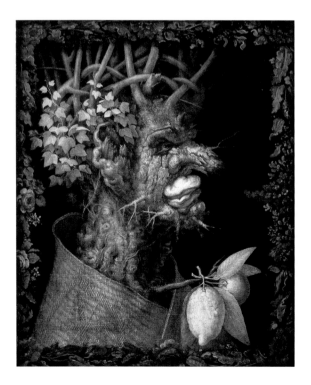

"advertisement" for the policies of the House of Hapsburg. Thus it was possible to maintain old links and to establish new ones – though probably not always to the unsullied delight of the recipients. However, it is difficult to imagine exactly how much of Arcimboldo's artistic activity was influenced by this sociological, utilitarian aspect of his art.

Arcimboldo's paintings, which have been interpreted mainly in terms of the history of human

Winter, 1573
Oil on canvas, 76 × 64 cm
Musée National du Louvre, Paris

Autumn, 1573
Oil on canvas, 76 × 64 cm
Musée National du Louvre, Paris

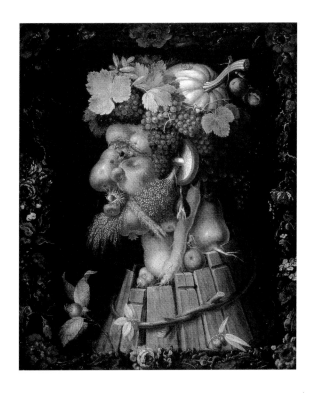

*thought, have been subject to a good
deal of discussion and have
therefore given rise to a considerable
variety of approaches and ideas.
The artist's cultural background,
i.e. his immediate environment at
the Emperor's court should be noted.
The Art and Wonder Chambers, in
particular, with their numerous rare
species and collector's items, must
have influenced Arcimboldo quite
considerably. There was always a
large number of stuffed animals
among them – documentary*

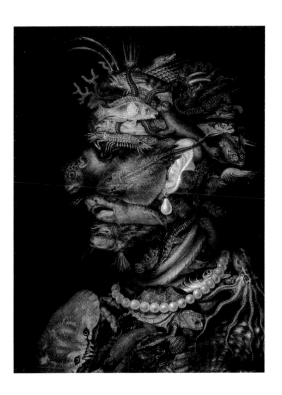

*evidence of an approach to natural
science that was as yet rather
unsystematic. Even at the Emperor's
court, a considerable portion of
educated society consisted of
alchemists and magicians, thus
showing that the distinction between
the arts and sciences was not as
clear-cut as it is today. Indeed, it
was by no means rare for an artist
to take an interest in "nature study"
and in contemporary technology, as
did Leonardo da Vinci and also
Arcimboldo.*

Water, 1566
Oil on wood, 66.5 × 50.5 cm
Kunsthistorisches Museum, Vienna

Arcimboldo's Pictures

Although Arcimboldo was extremely famous during his lifetime, he was soon forgotten after his death. There was almost no mention of him in the 17th and 18th centuries, and it was not until 1885 that a treatise by Dr. Carlo Casati appeared, called *Giuseppe Arcimboldi, pittore milanese,* in which he is mainly seen as a painter of portraits.

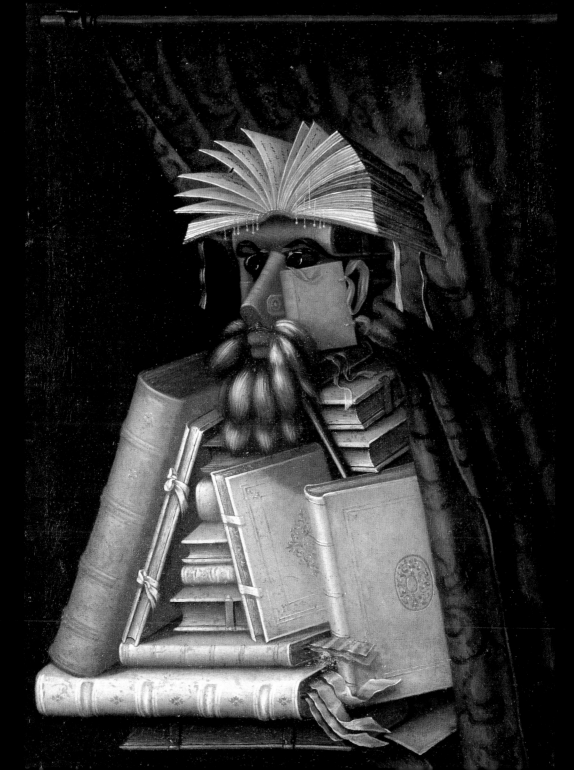

PAGE 29:
The Librarian, ca. 1566
Oil on canvas, 97 x 71 cm
Skoklosters Slott, Bålsta, Sweden

Benno Geiger describes this **Librarian**
as a "triumph of abstract art in the 16th
century" and says he knows of "nothing
more witty or closer to contemporary art
than this clever painting". It is indeed
quite clever, but more in the sense that
Arcimboldo had a bright idea; the
individual objects were painted quite
realistically and in the classicist tradition
of imitating nature. It was the artist's
idea that turned them into a librarian.
Hocke, who regards Arcimboldo as
one of the "most obvious forerunners"
of modern art, thinks of his pictures
as simple, easily understandable
translations. They were, however,
"painted with intelligence as well as
elegance, especially when we consider
the curtain, which has been lovingly
draped over the left shoulder of this
fleshless man who is suffering from the
cold."

OPPOSITE PAGE:
Spring, 1572
Oil on canvas, 76.6 x 57 cm
Private collection, Berlin

This picture of **Spring** belongs to the
second of four series shown in this book.
Two are complete, and two are without
Autumn.
When we compare several paintings
of the same theme, we notice that they
are very similar to the first ones that
Arcimboldo made, but never mere
copies. The overall composition was
always the same, but occasionally he
changed the format, and also the colour
scheme, though he always preferred a
dark background. Individual shapes were
changed with regard to size and colour.
Just as in a musical composition, we can
speak of variations on a theme.

A little later he was also discovered by artists. The
surrealists in particular regarded him as a precursor. In his
book *Die Welt als Labyrinth* ("The World as a Labyrinth")
Gustav René Hocke shows how pictures by Salvador Dalí and
Max Ernst contained some surprising, though rather
superficial similarities. Several articles on Arcimboldo were
published in the first half of the 20th century, and several
more detailed ones in the second half. In 1954 Benno Geiger
published his extremely thorough analysis *I dipinti ghiribizzosi
di Giuseppe Arcimboldi* , and the same year saw the publication
of *Arcimboldo et les Arcimboldesques* by Francine-Claire
Legrand and Felix Sluys. In 1977 André Pieyre de
Mandiargues wrote his poem *Arcimboldo le merveilleux,* and in
1978 Thomas DaCosta Kaufmann published a doctoral thesis
called *Variations on the Imperial Theme in the Age of
Maximilian II and Rudolph II.* Then there was *Arcimboldo* in
1980, with a text by Roland Barthes, and a book by Andreas
Beyer called *Giuseppe Arcimboldo. Figurinen,* in 1983. There
have been several other publications which cannot, however,
be referred to in this book. There has been a growing interest
in Arcimboldo, which is reflected in the large number of
exhibitions which have been arranged in his honour, not to
mention the prices which are paid for his pictures today.

We do not know why people ever lost interest in
Arcimboldo's art. Perhaps he was misunderstood by the
generation that followed, because they regarded him as no
more than a clown who used to paint rather odd, abstruse and
fantastic pictures, of which we only have a very few originals
nowadays. Apart from these fantastic pictures, he probably
painted quite a few more traditional ones. But many of these,
too, seem to have disappeared. As far as I know, it has only
been possible to identify two self-portraits (one of them a
drawing), the stained glass windows in Milan Cathedral and
the Gobelin tapestries in the Cathedral of Como. Stained glass
windows and tapestries were very popular at the time and
regarded as important in the history of art.

Present-day publications are mainly concerned with an
understanding of Arcimboldo's comical pictures, as Geiger
calls them, which were enthusiastically admired by the
painter's contemporaries and which are now studied with
great interest by art historians and critics. This is hardly
surprising: they really are unique. There have been
innumerable copies and imitations, but Arcimboldo's stature
has never been reached. At the Emperor's request,
Arcimboldo repeated his series of *The Four Seasons* and
Elements quite frequently. There was obviously a lot of
enthusiasm for these pictures, and the Hapsburgs knew how
to make use of it, by giving away paintings as presents.
Their intention was not only to give pleasure but also to win
supporters of Hapsburg political ideas.

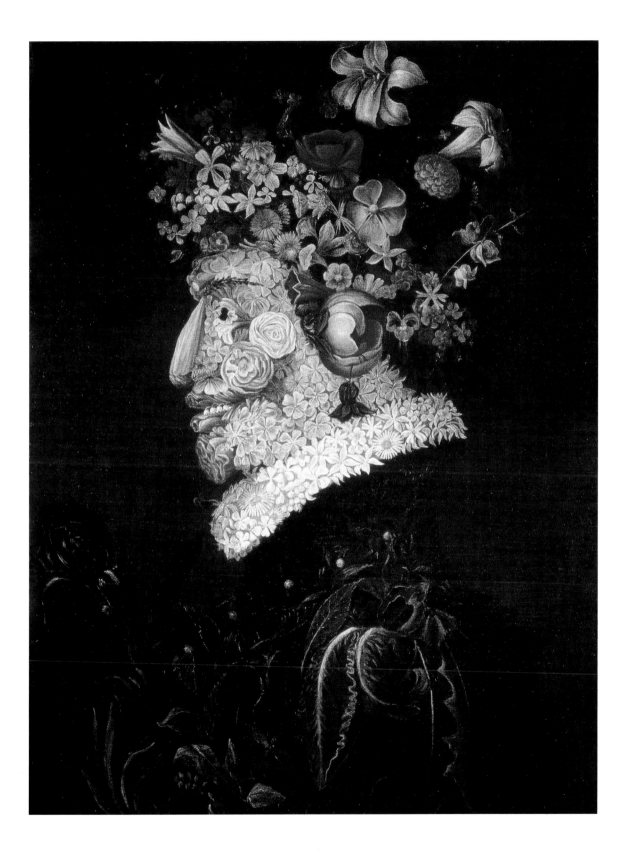

What is it that makes Arcimboldo's pictures so unique? A head in profile consisting of a thousand flowers is called *Spring,* another head made up of all kinds of fruit is called *Summer. Water* is the title of a painting in which all the creatures of the sea seem to have congregated in complete chaos. Then there is *Earth,* a head which consists of over forty different animals. A half-length portrait made up of books is a librarian. And there are many other compositions of this kind. The individual shapes, whether they are flowers, animals or fish, are always rendered accurately with regard to detail as well as delicate colours. Some of the pictures are in fact quite confusing. One particular painting, for instance, includes a pot full of different kinds of vegetables, but when you look at it upside down, it turns into the figure of a market-gardener.

If we inquire into the uniqueness of Arcimboldo's pictures, we are at the same time trying to understand them, and asking about the artist's cultural background and his philosophy. The publications of the experts listed above do not share a common approach. I shall therefore confine myself to a brief summary of their views, together with some quotations, and then leave the final conclusion to the reader. Geiger, whose book started off the entire discussion, shares the view of Arcimboldo's contemporaries. The title makes this quite clear: *The Comical Pictures of Giuseppe Arcimboldi.* The book itself fully corroborates the impression that Arcimboldo's pictures are "comical". Geiger's chief witnesses are, above all, Lomazzo, Comanini and Morigia, who described the paintings as precursors of "bar-room pictures" (DaCosta Kaufmann) and as "scherzo" or "bizarrie". This view was also held by P. A. Orlandi, who, in the 18th century, described Arcimboldo as an extravagant painter; and Luigi Lanzi spoke of his paintings as "capricci", i. e. jokes, which the artist had conjured up with his paintbrush. And there is of course Geiger himself, who uses the word "comical", although he does not intend any negative meaning.

That he does in fact think very highly of Arcimboldo's ability as an artist can be seen in a paragraph from the same page. He has a rather low opinion of the kind of "buffoons" who exist today and compares them with Arcimboldo: "I think if there are buffoons today, then that is nothing new. There have always been eccentrics who were probably also buffoons. But there is an important difference: if nowadays someone suddenly discovers the genius in him, even though yesterday he could not even draw, then that seems a bit insincere to me. When, on the other hand, the early pioneers discovered beauty in ugliness or vice versa, they were in fact faultless masters of their craft and, partly because they were relative beginners, had a certain straightforwardness about them. And because they were straightforward, they were

The comments on Arcimboldo's **Summer** in the Louvre also apply to this painting. There are only minor differences.

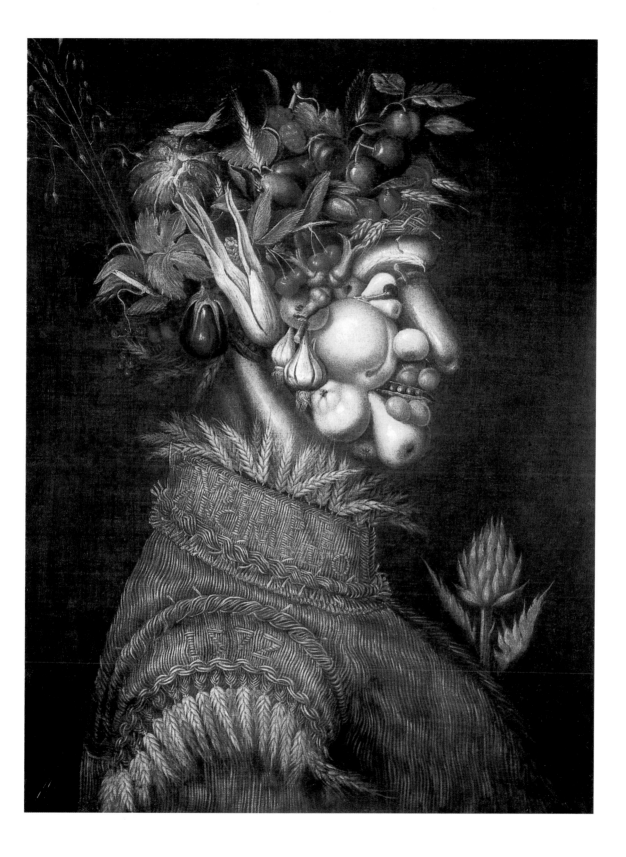

Autumn, 1572
Oil on canvas, 76.8 x 56.7 cm
Private collection, Berlin

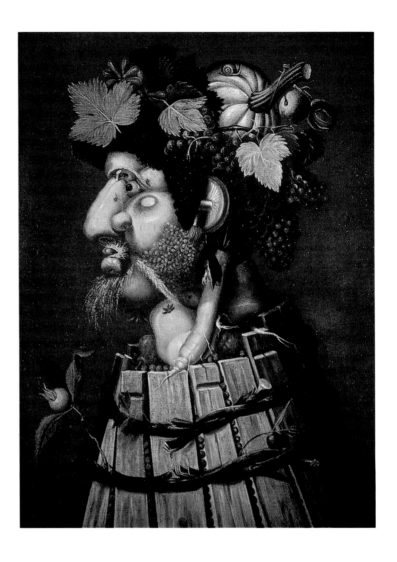

This picture of **Autumn** differs from the one in the Louvre through its sharp contrasts of light and darkness. Some of the grapes, for instance, are almost black, whereas the face is generally very bright indeed. The change of format is made necessary by the tub, which is longer than in the other picture. What is particularly striking, however, is the relatively light background, which is rare in Arcimboldo's art. Beyond that, there are only very few differences. The level of artistic quality is the same in both paintings.

original. Indeed, this ugliness surpassed all beauty and included the sort of satire that delighted the artist's customer, the jokes that were told again and again among the bored inhabitants of the various courts, it included those optical illusions and that artistic mimicry which Ficino, the famous Plato translator, used to call *simulacrum*. For me all this is just one more reason why it is worthwhile spending time and effort studying a painter who was indeed a genius, who used to entertain three emperors at the time of Titian and Tintoretto and who still entertains us today."

Geiger points out that his view of Arcimboldo's art is shared by Adolfo Venturi, a specialist in Italian art, who maintains that Giuseppe Arcimboldo's grotesque ideas have their roots in German etchings and in Leonardo da Vinci's

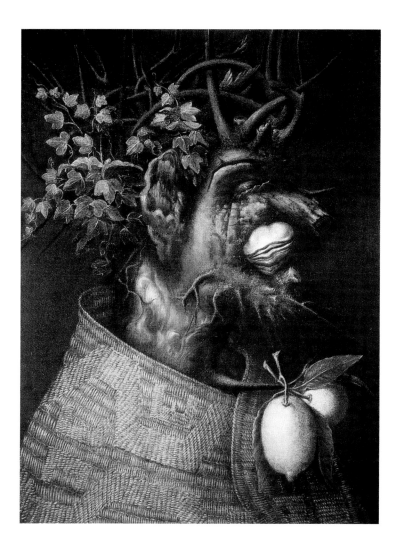

Winter, 1572
Oil on canvas, 76.8 x 56.7 cm
Private collection, Berlin

cartoons: "It really seems as if Leonardo had guided the master's hand."

Geiger also believes that Arcimboldo's art was influenced by his environment, the Imperial court, his activities in the Art and Wonder Chambers and the company of learned men, including alchemists and magicians, who constantly surrounded the Emperor. Furthermore, he thinks it is quite likely that Arcimboldo was influenced directly "from above", that he received advice and suggestions from the Emperor himself. He says that the emperors had so much political discontent on their hands, so much internal strife caused by warring religous factions, that in the midst of all this they wanted to have some entertainment, relaxation and peace, at least within their families, and so they took great delight in the

As in the corresponding picture of **Autumn**, Arcimboldo emphasized the vertical dimension far more than he did in the painting of **Winter** in the Louvre, especially with regard to formal composition. But there are also differences in colour and surface structure. Take the bark of the tree stump: in his Louvre picture Arcimboldo emphasized the sharp contours and the ruggedness of the bark, whereas in this one he preferred a more blurred and gentle depiction of the surface.

The Lawyer, 1566
Oil on canvas, 64 × 51 cm
Statens Konstsamlingar, Gripsholm
Slott, Stockholm
Inscription on the reverse:
Giuseppe Arcimboldo, F 1566

Benno Geiger thinks this is a portrait of
Calvin, whereas Sven Alfons maintains
that Arcimboldo painted the lawer J. U.
Zasius, who was one of Rudolph II's
closest advisors. According to Comanini,
it is the protrait "of a certain scholar
whose entire face had been eaten by the
French disease, so much so, in fact, that
only a few little hairs had remained on
his chin… He composed his face entirely
of meat and fried fish; and it turned out
to be such a successful picture that
everyone who looked at it immediately
recognized the true face of the law
scholar." The man's face is indeed a
ghastly sight, especially the eye of the
plucked chicken which, still alive, is also
that of the man in the portrait. Although
his body is robed in a magnificent cloak,
it contains nothing but thick books and
files.

artistic jokes and comical pictures that Arcimboldo provided.
Elsewhere in the book, however, Geiger expresses himself
more cautiously about the influence of the court on the artist's
style: "Whether Arcimboldo had a natural tendency towards
cartoons and an illusionist style of painting or whether he had
received instructions from his employers, who wanted to
make fun of certain individuals – it is certainly true to say that
he took a completely new path during his time in Prague, that
he stubbornly persisted in creatin a style of his own which had
never been seen before and was so unique that he is still
famous for it today."

Literary movements and the fine arts have always
influenced each other. Geiger points out one particular link
which, he says, shows Arcimboldo's ideas of art. A
contemporary of Arcimboldo's, Rabelais, had written a novel
in which he "cracked his satirical whip at everyone and
everything like no one before him". The book was
subsequently translated into German by Fischart, who also
wrote a number of satires himself. These books were later
illustrated by Tobias Stimmer. Geiger describes one of these
illustrations, which is indeed very similar to Arcimboldo's
paintings. It is a picture of the Pope, whose figure, as in
Arcimboldo's art, consists of individual objects, with the
intention of ridiculing the Pope. However, the similarity is
purely superficial, because Arcimboldo's intention in his
pictures was completely different, with the exception of one
painting which Geiger sees as a take-off of Calvin. He admits,
however, that he cannot really be sure that it is a picture of
Calvin. Opinions do vary. Neither can we be certain about the
satirical intention of a number of other paintings quoted by
Geiger, because they no longer exist. To conclude my
summary of Geiger's approach to Arcimboldo, let me quote a
passage from his book which shows that even Geiger regarded
the artist as more than a painter of comical pictures.
According to Geiger, a line from a sonnet, *There's Neither
Shape nor Form in it,* reveals "the painter's secret intention,
which was more that of a philosopher than a superficial glance
might lead us to believe. His method was to cast a cloak of art
over nature, that is, to present the truth by disguising it. It was
the logical consequence of the surrealist style he had acquired,
or, as Comanini's Figino puts it: "Arcimboldi's skilful
depiction of the imperceptible by means of perceptible
illusions was quite unique."

DaCosta Kaufmann looks at a completely different
aspect in his thesis *Variations on the Imperial Theme in the Age
of Maximilian II and Rudolph II.* DaCosta Kaufmann
advocates a serious interpretation of Arcimboldo's art in the
context of the culture in which he lived. He believes that
recently discovered texts correct the view that Arcimboldo's
pictures are amusing, eccentric and imaginative brainwaves.

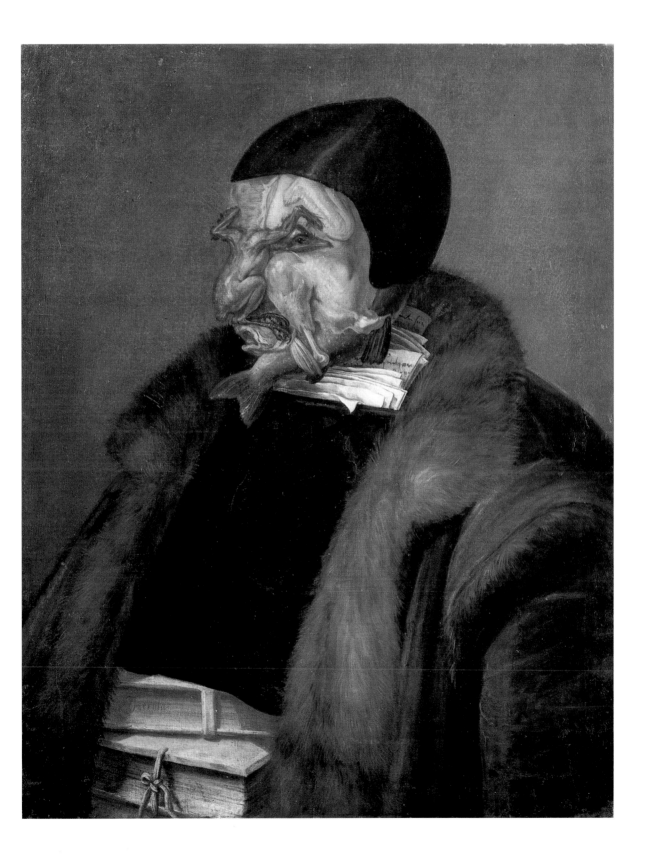

The Lawyer, undated
Oil on canvas, 70 × 54 cm
Private collection, Milan

Recent research has revealed that this second version of **The Lawyer** is probably not by Arcimboldo, even though it is very similar to the first one. The two most striking similarities are in the face and the large fur collar, whereas the plain chest in the first picture is quite different from the richly decorated one in the imitation. A thick chain with a large medal, almost reaching the man's stomach, hangs over an elaborately ornamental chest. The man in the protrait is probably Dr. J. U. Zasius, one of the closest advisors of the Emperor, and he may well have been given this particular medal and also the picture for his service.

The Cook, a visual pun which can be turned upside down, ca. 1570
Oil on canvas, 52.5 × 41 cm
Private collection, Stockholm

Lurking in a big dish there is the head of a rather rough-looking chap, but when we look at it more closely it turns out to be composed of chunks of fried meat. When we look at the picture upside down, the helmet turns into a meat dish, with a slice of lemon lying on the edge and piles of fried meat in the middle. We can easily make out a sucking pig and an oddly distorted chicken. Somebody is about to cover the meat with a lid, to stop it from getting cold.

The Vegetable Gardener, a visual pun which can be turned upside down, ca. 1590
Oil on wood, 35 × 24 cm
Museo Civico Ala Ponzone, Cremona

The picture as we see it here is upside down, in a sense. It shows a dark green bowl filled to overflowing with various root vegetables.
When we turn the picture round by 180°, this bowl full of vegetables turns into a head, chubby-faced and unpolished like the vegetables themselves.

He sees the portrait of Rudolph II, *Vertumnus,* not as a "bizarre" joke to make the Emperor laugh, and he rejects Geiger's view who regards Arcimboldo's paintings as "dipinti ghiribizzosi". Neither does he accept Francine-Claire Legrand and Felix Sluys' approach to Arcimboldo's art as "bizarreries picturales", or Paul Wescher's, who sees these paintings as "parodistic expressions of the microcosm-macrocosm idea." Rather, he prefers the interpretation given by Sven Alfons, Pavel Preiss and R. I. W. Evans, who regard Arcimboldo's paintings as a "system of correspondences between microcosm and macrocosm, the Aristotelian theory of the elements." However, DaCosta Kaufmann develops his approach to Arcimboldo's art on the basis of a newly discovered poem by Giovanni Battista Fonteo, called *The Paintings of the Four Seasons and the Four Elements by the Imperial Painter Giuseppe Arcimboldo,* as well as a compendium of documents in connection with the festivities in Prague 1570 and Vienna 1571. He takes it for granted that Arcimboldo, who used to work closely with Fonteo, approved of Fonteo's ideas. Fonteo's manuscripts give us quite a lot of insight into Arcimboldo, explaining his art in terms of "Imperial allegories" which went beyond the purely visible and telling us how the subjects of the pictures were related to daily life at the court. They culminate in the statement that the depiction of Rudolph II as Vertumnus constituted a glorification of the Emperor. That there was indeed a close link between Fonteo's poem and Arcimboldo's pictures became obvious in the New Year celebration of 1569. It was customary for the Emperor's subjects to give him a New Year present. Fonteo's poem accompanied The Four Seasons and The Four Elements which Arcimboldo gave to Maximilian II. This shows that the pictures must have been Imperial paintings. The Emperor liked them so much that he had them put in his bedroom. What could have been more appropriate as a present to the "King of Kings" than the seasons and the elements of which the year and the earth consist?

DaCosta Kaufmann believes that the word *grilli* must have led to the wrong interpretation of Arcimboldo's works, even though Fonteo's poem should have made it quite obvious that the pictures were a glorification of the Emperor. The word *grilli* as used by Fonteo was understood by Lomazzo and his successors in its normal sense of "capricious", "amusing", "facetious". But pictures can hardly glorify the Emperor if they are meant to be amusing or facetious. On further investigation, DaCosta Kaufmann came to the conclusion that *grilli* must have had a different meaning in connection with Arcimboldo's pictures. The word could really only refer to the unique and unusual way in which an idea is expressed in the form of heads consisting of different objects, such as a farmer shown by his plough, a cook by his

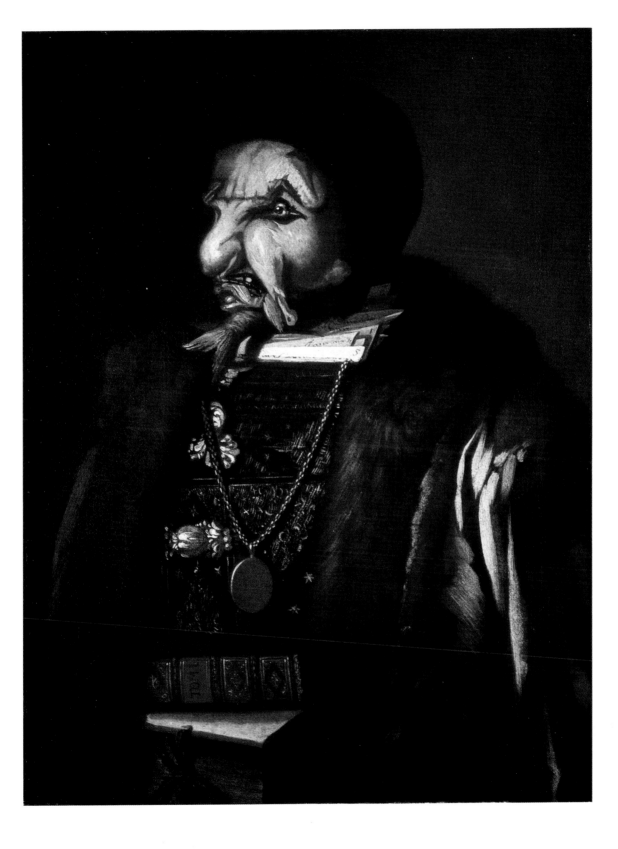

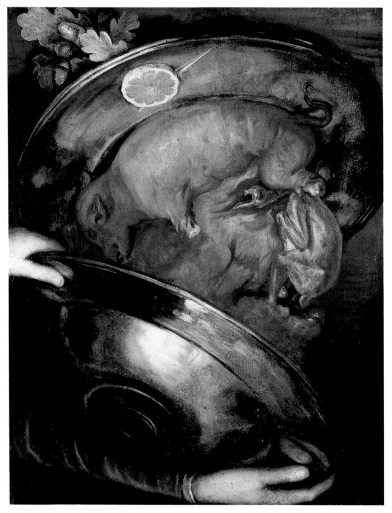

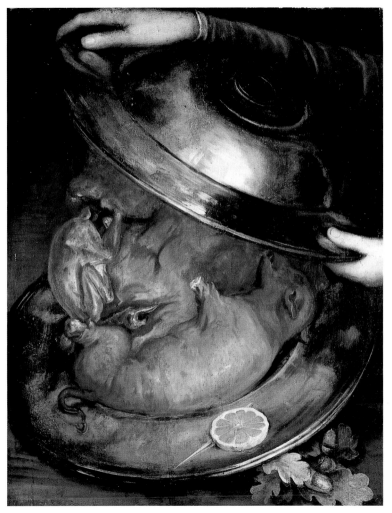

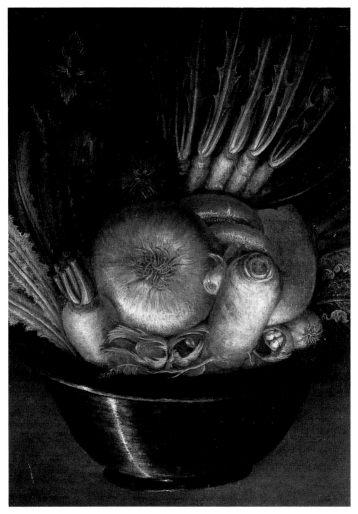

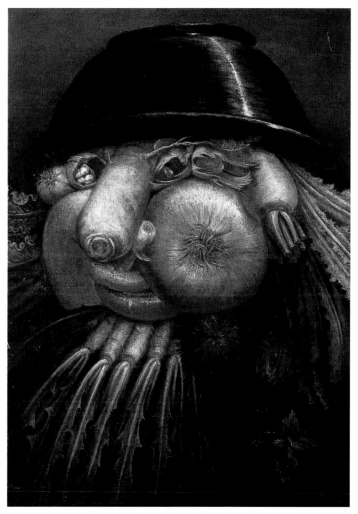

Arcimboldo's Vertumnus

As Arcimboldo had promised Rudolph II, he continued to
paint for the Emperor after his final return to Milan. His
pictures of that period include one that was particularly
appreciated by everyone, especially by Rudolph himself. It is a
head-and-shoulder portrait of the Emperor, this time not in
profile, showing him in the form of Vertumnus, the ancient
Roman god of vegetation and transformation. Rudolph
consists entirely of magnificent fruits, flowers and vegetables
representing the four seasons. Plants and produce of the
whole year have been gathered together "in perfect harmony",
to glorify the Emperor who rules over them like the god
Vertumnus. This picture is the crowning achievement among
all the paintings that Arcimboldo made for the glory of
Rudolph II or the other Hapsburg rulers. Nobody ever
succeeded in giving a better interpretation of the portrait than
Arcimboldo's friend and contemporary Comanini, whose
poem is given here in an English translation of Geiger's

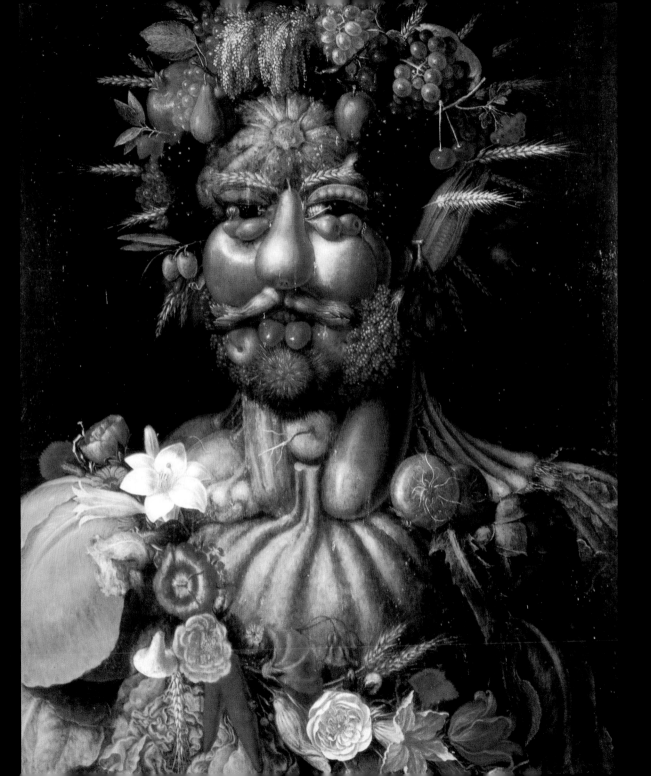

Vertumnus, 1590 or 1591
Oil on wood, 68 × 56 cm
Skoklosters Slott, Bålsta, Sweden

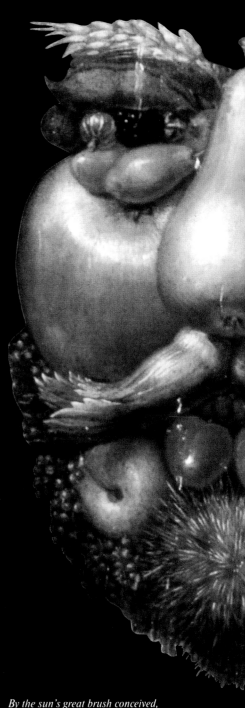

Whoever you may be, when you behold
This odd, misshapen picture which is
 me,
And there is laughter on your lips,
Your eyes are flashing with hilarity,
And your whole face is seized by mirth
As you discover yet another monstrous
 detail
In him who bears the name Vertumnus,
Being thus called in poems of the
 ancients
And by Apollo's learned sons;
Unless you clearly see that ugliness
Which makes me beautiful,
You cannot know that there's a certain
Ugliness more beautiful than any
 beauty.
There's diversity within me,
Though despite my diverse aspect, I am
 one.
That diversity of mine
Renders faithfully and truly
Diverse things just as they are.
Raise your eyebrows now and frown,
Listen hard with concentration,
Lend your ear to what I say
That I may entrust you, friend,
With the secret of new art.
In the beginning there was chaos,
Shapeless, void and dark the Earth,
Even heaven was mixed with fire,
Fire with heaven, and heaven with fire,
Air and water intermingled
With each other and with Earth,
Which, in turn, was mixed with Fire
And with Air and Water, too:
There was chaos without order,
Without shape and without form.
Then came Jove and raised his arm
Lifting up the Earth above the water.
Air was now upon the water,
Water round the Earth,
And Fire round the Air:
Each surrounded by the other,
Firmly sealed and closely knit,
Dryness, moisture, warmth and cold,
Like four rings surrounding firmly
Many precious, costly stones.
Heaven, though, received the honour
Of the noblest of all thrones,
Ruling, dominating, gath'ring
All the other elements.
Thus, from shapeless chaos

From confused and formless waters,
Like a new-born animal,
Noble, perfect, full of life,
Born as of a fertile womb,
Into being came this world.
And its face is called Olympus,
Eyeing us with many stars,
Air's the chest, and Earth the belly,
Mountain valleys are its feet,
And the soul which warms and
 quickens
And enlivens this great body
Is the element of Fire;
Clothed in produce of the earth,
Wearing plants and fruit and grass.
How then, do you think, my friend,
Did the painter go about it,
How did Arcimboldo paint me,
The inventive genius,
With a brush that far surpasses
That of Zeuxis or of those
Who created veiled deceptions,
Delicately beautiful,
In their contest for great fame?
Boldly imitating Jove,
Joyfully he set to work,
Went through fields and woods, and
 chose
A thousand flowers, thousand fruits,
Set to weave this cheerful mixture,
This great product of creation,
Into an artistic garland
Of his own, and himself creating limbs,
Cleverly deceiving you.
Come, behold my temples,
And admire that which makes them
 beautiful
Colourfully decked they are
By so many ears of corn,
Spiky, full of Junius' pollen,
Golden, ripened by the sun,
Finally cut down and reaped
By the farmer's mighty scythe,
That sharp sword in his clenched fist.
Fields of corn are thus prostrated,
Golden millet which in winter
Serves the shepherd in the mountains
As a sweet delicious meal
For his wife and for his children,
In his humble little hut.
Grapes are hanging from my temples,
Softly contoured, warmly painted,
Gently stroked by rays of sunshine.

By the sun's great brush conceived,
Painted red and painted yellow,
Reaped and harvested at last
In Lyaeus' golden month.

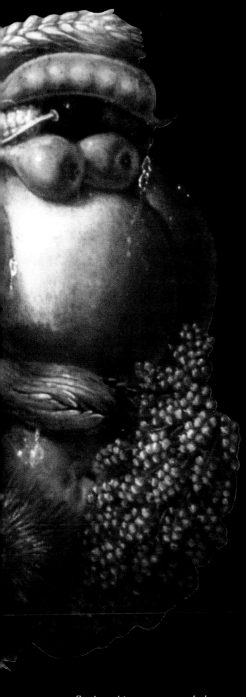

DETAIL FROM:
Vertumnus, 1590 or 1591
Oil on wood, 68 × 56 cm
Skoklosters Slott, Bålsta, Sweden

Who adorned his kingly head
With a long and twisted ribbon,
Twisted like a thousand loops,
He whose eyes would glow with ardour
And with lofty royal pride.
Behold that summer fruit, the melon:
When the dog is barking at the sky,
When the lion in the mountains
Draws deep breath and roars out loud
So that here below we hear him,
In our houses, hostels, caves,
By the river, at the spring,
Then the melon will refresh us,
Will revive our dried-up throats,
With its sweetness and its moisture
It revives a noble king,
As it does a lowly peasant
And a nymph's large company,
Also thirsty warriors
Are refreshed by its sweet juice.
Look, how with its furrowed pattern,
With its tough and wrinkled skin,
It produces wrinkles on my
Forehead so that I am like
The old ploughman in the mountains,
Whom Bohemia's soil sustains
And his labour hard and toilsome,
Twixt the ice and stone and wood,
Sombre, dark and oddly shapen.
Behold the apple and the peach:
See how my two cheeks are formed,
Round and full of life.
Also have a good look at my eyes,
Cherry-coloured one and mulberry the
 other
Though there may be no resemblance
With Narcissus, yet I share
With this healthy, cheerful brother
Both his youthful, joyful vigour
And his potent manfulness,
For his eyes would gleam and sparkle
With the harvest of the grapes,
When he wined and dined, enjoying
Fellow-warriors' company,
Till the wineskins were all empty.
Look at those two hazelnuts:
With their green and empty skins,
Side by side above my lip,
Though they're useless otherwise,
Yet they render service as two sides
Of a nicely trimmed moustache.
As a complement to these
There's a chestnut's spiky case

Clinging to my chin and making
It a perfect miracle
Of adornment, fitting for a man.
Ha, where is Iberia's master
Who so aptly moulds and fashions
All that wool upon his head,
Long and sharp and fine to touch,
Which he often with his fingers
Playfully, artistically,
Twists and strokes till,
Like an eyelash, it points upward?
Where then is he who might want
To compete with this new beard?
Also, friend, I beg you, take
Notice of this fig which ripened,
Then burst open and now dangles
From my ear, so that you may
Well mistake me for a little
Frenchman who, as he is standing
By the Seine, puts bright pearls
Upon his earlobe, and, thus proudly
 decked,
Struts around, as pretty now
As a little flower, breathing
Loveliness and charm and splendour.
Finally behold this sash – not to
Mention all the other strong and
Handsome limbs –
woven, so it seems, from
Many flowers, fine as gold,
Draped around my chest and my right
 shoulder
Thus you'll surely value and appreciate
As a loyal vassal me,
As a warrior proud and strong,
Riding boldly, cheerfully and proudly
On my path to victory in battle,
Holding forth triumphantly my Sove-
 reign's
Colours and his coat of arms.
What uplifts me even more, though,
Is the way in which I proudly
And with joy aspire unto heaven,
Like Silenus, that young Grecian
Who delighted his good king,
Who was honoured, too, by Plato.
Though my aspect may be monstrous,
I bear noble traits within,
Hiding thus my kingly image.
Tell me now if your are willing
To discern what I conceal:
Then my soul I will reveal.
 Don Gregorio Comanini

See how this arrangement decks me,
Decks my temples high and round,
Sumptuously and beautifully
Like that famous Thracian's features,

Flora, ca. 1591
Oil on wood, 73 × 56 cm
Private collection, Paris

Apart from **Vertumnus,** Arcimboldo also painted **Flora the Nymph** in Milan in 1588, followed by a second version two years later. The first picture bears the inscription on the other side: "La flora dell' Arcimboldo". According to B. Geiger, this painting was "praised by many spirited people in Latin and with popular poems". Don Gregorio Comanini welcomed it with the following madrigal:

Son'io Flora o pur fiori?
Se fior, come di Flora
Ho col sembiante il riso? E s'io son Flora,
Come Flora è sol fiori?
Ah non fiori son'io; non io son Flora.
Anzi son Flora, e fiori.
Fior mille, una sol Flora;
Vivi Fior, viva Flora.
Però che i fior fan Flora, e Flora i fiori.
Sai come? I fiori in Flora
Cangiò saggio Pittore, e Flora in fiori.

We only have the second picture now, which, according to Mandiargues, is a "high-quality later replica" of the original. He praises the "pure beauty of the figure, the subtle way in which the shades of colour have been attuned to one another so harmoniously". A well-proportioned, handsome face looks at us from the darkness of the background. The delicately coloured petals subtly range from white to pink, and the fine transitions between light and dark highlight the youthful face of a woman whose hair consists of a multitude of colourful flowers that frame her head like a wreath or a crown. Round her neck she is wearing a collar consisting of white blossom which is livened up by a number of yellow dots, the stamens of the flowers. This collar separates the leaves that form her dress from her neck and face. The woman's chest is adorned by a yellow lily, traditionally a symbol of fertility.

cooking utensils. This was certainly unique. According to Fonteo, there had never been anything like it, even if one went back to Alexander the Great and his legendary painter Apelles. Art historians have always found it difficult to identify Arcimboldo's pictures. DaCosta Kaufmann only recognizes four pictures which can be regarded as originals because of the artist's signature. A number of paintings were described in the same way by contemporaries, and there is therefore little doubt that they are genuine. Others are part of series of paintings that were never separated. But there are also several pictures which are not uniformly acknowledged as genuine by all art historians. The greatest difficulty is that Arcimboldo was often asked to repeat his series, and he always did this with a number of differences of varying importance, so that we often have more than one original.

According to DaCosta Kaufmann, the idea of the glorious majesty of the Emperor was based on the Renaissance concept of the relationship between microcosm and macrocosm. There is a principle of equality which unites the different parts of nature, i. e. the world at large (the macrocosm), and it also exists between macrocosm and microcosm. The microcosm is the smaller world of man himself.

"Similar things are seen as related to one another." Thus what seems at first sight rather exaggerated becomes acceptable allegory. The Emperor rules over the state, over the microcosm, over man. But as there are many levels on which the microcosm corresponds to the macrocosm, he can also be said to rule over the seasons and the elements.

The way in which the various heads in Arcimboldo's pictures are composed of certain elements confirms Fonteo's idea that the Empereor rules over the seasons and the elements. Thus, the harmony of the fruit or the animals that make up a head symbolizes the harmony which exists under the benevolent rule of the Hapsburgs. Similarly, there is also harmony between the elements and the seasons, symbolizing peace under the rule of Maximilian II. Always based on the principle that similar things must be related, Fonteo talks at great length about the harmonious relationship between elements and seasons. Thus, both seasons and elements are linked to one another and share the same properties. "Summer is hot and dry like fire, winter is cold and wet like water, both the air and spring are hot and wet, and autumn and the earth are cold and dry." Fonteo goes even further in his interpretation. Proserpina, the goddess of winter, and Neptune, the god of water, are friends, and that is why winter and water belong together. In spring it is the air that makes the flowers blossom. Summer and fire have a common planet, the sun; earth and autumn have the moon. The seasons and the elements enter into a number of dialogues in Fonteo's poem,

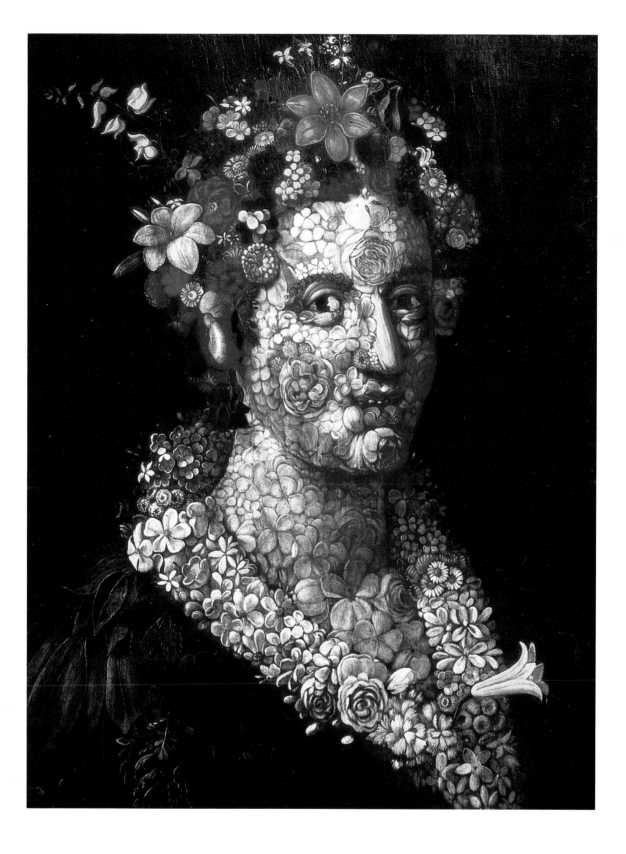

Spring, 1563
Oil on oakwood, 66 × 50 cm
Museo de la Real Academia de Bellas
Artes de San Fernando, Madrid
Signed in the lower right-hand corner:
Giuseppe Arcimboldo. F

This picture, which is now in the Real
Academia de Bellas Artes de San
Fernando in Madrid, was painted by
Arcimboldo for Ferdinand I in 1563, and
is thus part of the first known series of
the Four Seasons, two of which are in the
Kunsthistorisches Museum in Vienna
(**Summer** and **Winter**). This painting of
Spring may have reached Spain as a gift
to Philip II. The reverse side bears the
incomplete inscription: "Spring,
accompanied by Air, which…", thus
confirming DaCosta Kaufmann's
suggestion that the Four Seasons and the
Elements formed certain pairs which
were linked in a special way. The
inscription obviously suggests that **Spring**
and **Air** belonged together. It also
explains why Arcimboldo depicted those
heads in profile: the members of each
pair were meant to face one another.
This 1563 series was painted by Arcim-
boldo, as Geiger puts it, after he had
"taken a completely new path during his
time in Prague", where he "stubbornly
persisted in creating a style of his own
which had never been seen before and
was so unique that he is still famous for it
today."

extolling and glorifying the monarch. And if we take a close
look at Arcimboldo's pictures, we can see something of these
dialogues in them, too. The various elements and seasons are
all in profile and seem to be facing one another: *Winter* and
Water, Spring and *Air, Summer* and *Fire, Autumn* and *Earth.*

Each series also contains a certain symmetry. Two heads
are always looking to the left and two to the right. But the
correspondences go even further. The world consists of the
elements, and whoever rules over the elements will control
the world, and so the Emperor will break the power of the
Turks. The four seasons return every year, thus symbolizing
the eternal order of nature as well as the idea that the
Hapsburgs will reign forever. This also explains the shape of
the heads in Arcimboldo's pictures. However, we must bear in
mind that there had already been a long tradition of depicting
the four seasons in the form of heads. Roman coins in
particular used to have decorated heads on them, and there
must have been Roman coins in Rudolph II's coin collection.

According to Arcimboldo and Fonteo, however, there
was one particular classical source for these heads: an ancient
legend connected with the construction of the Jupiter temple
on the Capitol. The tale is told by Dionysios of Halicarnassos
– and also, in a slightly different version, by Livy – that the
builders of the Jupiter temple suddenly hit upon a head that
kept bleeding, but, according to Livy, still had its facial features
completely intact. A soothsayer explained that the place where
the head was found was to be the "head" *(caput)* of all Italy.
Hence the name Capitolium and the Latin word *capita* for
"heads". Livy says that this place was to be the centre of the
empire as well as the "head" *(caput)* or capital of the whole
world. Thus the heads of the seasons and of the elements
stand for the eternal rule of the House of Hapsburg.

According to Fonteo, the political significance of these
pictures is further emphasized by the large number of
Hapsburg symbols, such as the peacock and the eagle as part
of *Air.* The element air is ruled by these two animals. *Fire,* too,
can be shown to have such a double meaning. On the one
hand, the element fire is symbolized by the chain of the
Golden Fleece, a chain which consists of flintstone and forged
steel which can be knocked together to light a fire. But on the
other hand, there was also the Order of the Golden Fleece – a
Hapsburg order. And the same picture contains a number of
obvious military references.

Earth is another picture which is full of Hapsburg
symbols, such as the lion's hide of Hercules and the skin of a
ram. The lion, says Fonteo, is in fact a symbol of the Kingdom
of Bohemia, one of the provinces that belonged to the
Hapsburgs. There may also be some symbolical significance of
the precious pearls of *Water,* as well as antlers and a number
of other details.

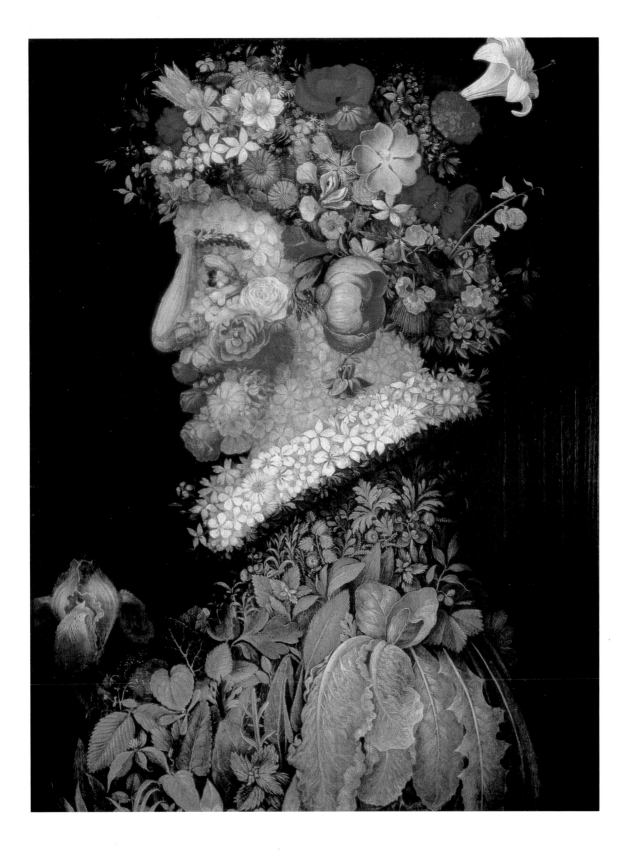

Summer, 1563
Oil on limewood, 67 × 50.8 cm
Kunsthistorisches Museum, Vienna

The Four Seasons contain similar references. *Winter,* for example, is shown to be wearing a coat which is adorned by a sign symbolizing forged steel and also by a capital letter M. Thus we can safely assume that the forged steel of the Golden Fleece is meant and that the M stands for Maximilian. And if, in another painting of *Winter* which was meant for the Elector of Saxony, Arcimboldo included the coat of arms of Saxony, then it seems sensible to interpret the picture in the same way. But, as Fonteo explains, winter also has a second meaning.

For the Romans winter was always the beginning of the year, and they therefore called it *caput anni. Caput,* however, also means "head". This means that if a depiction of winter can be directly related to Maximilian, then this is a pun on winter as the *caput anni,* the beginning of the year, as well as Maximilian as the *caput* (head) of the whole world. In fact Maximilian II took part in the festive procession of that year, 1571, dressed up as "winter".

DaCosta Kaufmann emphasizes the close link between Arcimboldo's pictures and his designs for processions. Both his paintings and his feasts are allegories of the power of the Emperor and the harmony of the world under his benevolent rule.

André Pieyre Mandiargues has his own attitude towards the various attempts to "understand" or "comprehend" Arcimboldo's art: "I have not been seized by the mad desire to classify everything; in my opinion, if one loves and respects the history of art, one should be quite happy for it to remain a little obscure." Mandiargues believes that Arcimboldo is "perfect in his uniqueness, as are only the great". That his affinity with the artist was of a very personal kind can be seen in his comment when he saw his pictures for the first time. This was at the Kunsthistorisches Museum in Vienna in autumn 1931: "All of a sudden I found myself face to face with four pictures: two 'seasons', one 'winter' and one 'summer', and two 'elements' 'fire' and 'water'. I stood as if touched by a magic hand." And a little further on: "The structured chaos of those odd faces was animated by such incredibly lively eyes and those eyes were so incredibly powerful and expressive that it is hardly surprising that one should be absolutely thunderstruck at first sight."

This is Mandiargues' approach throughout the whole book, and it explains why he refuses to classify or pigeonhole Arcimboldo's style in any way whatsoever. He discusses a number of options, but does not take any sides. For example, he does not reject the term "mannerist", because almost the entire sixteenth century can be called mannerist, with the exception that Arcimboldo's pictures do not tell stories or dreams. Similarly, he also accepts the term "baroque artist" for Arcimboldo, because of his "ability to shock and his tendency towards masquerades". On the other hand, however, he points

This picture of **Summer,** which is now in the Kunsthistorisches Museum in Vienna, forms part of Arcimboldo's first series of the Four Seasons, together with **Winter** (also in Vienna) and **Spring** (Madrid).
Like other pictures of **Summer,** it bears the inscription "Giuseppe Arcimboldo F." on the collar of the figure. There are only minor differences from the one in Paris, whereas it differs more obviously from Arcimboldo's **Summer** in Bergamo, both with regard to composition and in the design of the head dress.

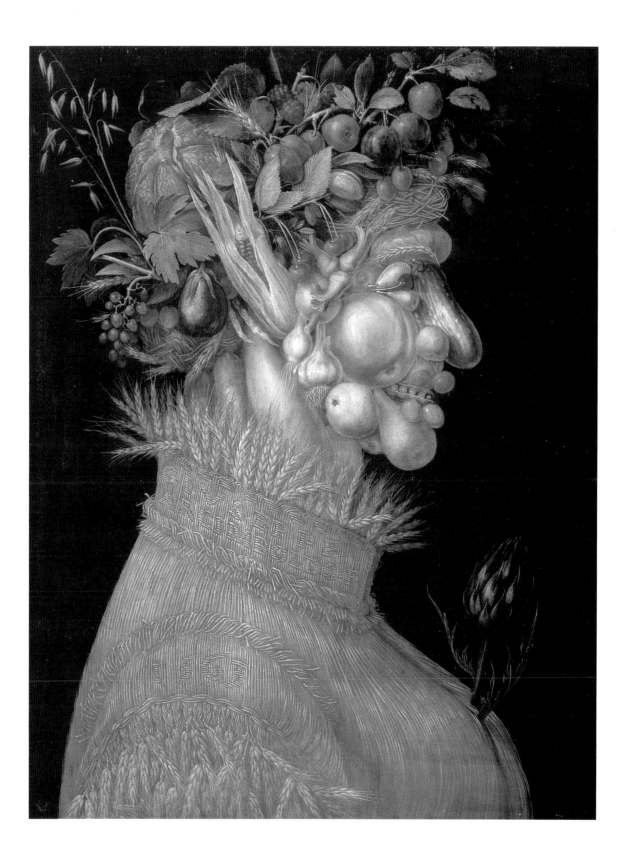

Winter, 1563
Oil on wood, 66.6 × 50.5 cm
Kunsthistorisches Museum, Vienna
Signed in the lower right-hand corner:
Giuseppe Arcimboldo F.
Date and title on the reverse: 1563 Hjems

Winter was conceived rather differently
from the other four seasons. It is not a
tête composée in the same strict sense as
Spring, Summer or **Autumn.**
The other three seasons are presented as
a variety of equally important plants,
fruits and flowers, whereas Arcimboldo's
picture of **Winter** consists of a central
element, a tree stump in the shape of a
head, which dominates the entire
composition. Both in form and structure
there is a strong similarity between the
tree stump and the wrinkled hand,
stubbly beard and thick lips of an old
man, thus arousing sympathy in us and
involving us personally far more than the
plants and flowers which, on closer
inspection, tend to lose their function
within the picture as a whole.

out that the "convulsive" element of the baroque period is
missing in Arcimboldo's art. Mandiargues would be prepared
to accept "pre-romantic" as a description, were it not for the
lack of a "feeling for nature" and of the "lyrical" element. He
does agree with the term "fantastic", as used by Plato in
Sophistes and also by Comanini, "who made use of Plato's
arguments in the neo-platonic dialogue *Figino* and applied
them to our painter."

He rejects any comparison with Hieronymus Bosch's
"pre-surrealist" style, because he cannot see anything in
Arcimboldo's art that might have come from his subconscious
mind or that might have been created automatically. "Playful,
humorous at times" seems to be all right as a description,
but Mandiargues thinks it would be wrong to see the artist
entirely in those terms, as many of his contemporaries used
to. He would not want to see Arcimboldo's pictures classified
as "symbolist", among other reasons because he believes that
"nothing is veiled anywhere" in his paintings. The most
appropriate term, he says, might be that of "anthropomorphic
still lifes" because it applies to nearly all the figures he
painted, including the two pictures that can be looked at
upside down.

Geiger was enthusiastic about Arcimboldo's comical and
mysterious pictures, DaCosta Kaufmann saw in his art mainly
the glorification of the Emperor and support for the existing
power structures, and Mandiargues was simply full of
enthusiastic euphoria. In his book *Die Welt als Labyrinth* ("The
World as a Labyrinth"), Gustav René Hocke tried to interpret
Arcimboldo's art in the context of mannerism. But before
discussing this, we must have a brief look at Arcimboldo as a
Renaissance artist.

Every artist develops under the influence of the cultural
environment in which he lives. And as Arcimboldo was born
during the transition period between the Renaissance and
Mannerism, we can find traces of both movements in his art.
His first pictures were painted in the traditional style of the
Renaissance. Even later, as a court artist, he used to paint in
this style again and again, and possibly was even required to
do so in his portraits. To give a comprehensive view of
Arcimboldo, I have included not only mannerist pictures but
also some of his traditional paintings. They can be regarded as
typical of the Renaissance. As Geiger points out, there was a
decisive turning point in Arcimboldo's art: in Prague he trod a
completely new path, stubbornly persisting in creating a style
of his own which had never been seen before and was "so
unique that he is still famous for it today". To show the
difference between his pictures before and after his turning
point, it will be necessary to give a short summary of the main
features of Renaissance art.

The Renaissance marked a clear break with the Middle

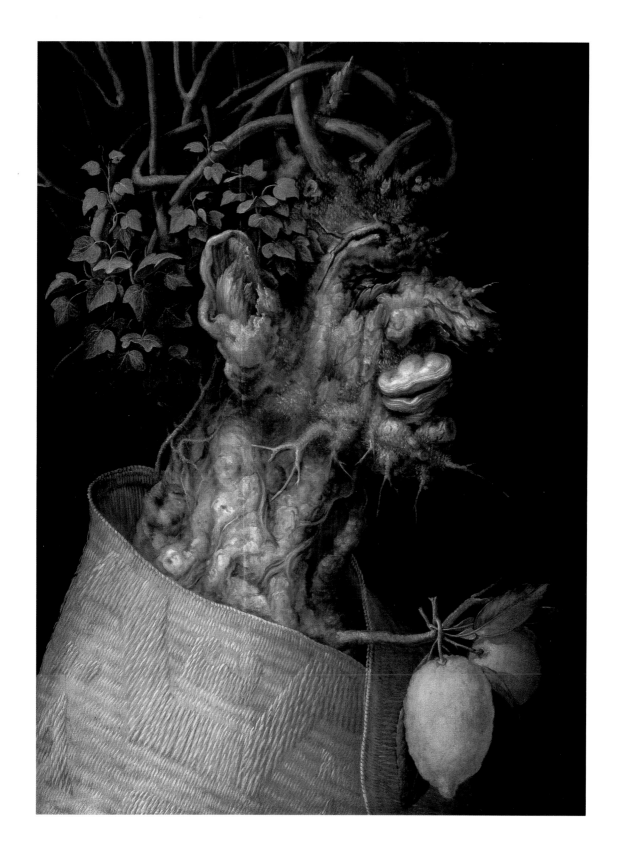

Spring, undated
Oil on wood, 84 × 57 cm
Bayerische Staatsgemäldesammlungen,
Munich

Ages as well as an interest in nature and antiquity. Leonardo da Vinci maintained that "the most praiseworthy painting is one which has the highest degree of similarity with the subject, in spite of what some painters say who want to improve nature." This shows that nature was taken as the starting point for any artistic activity. The idealistic paintings of the Renaissance, however, used to go beyond a mere study of nature, perspective and anatomy; the artist aimed at "harmony of colours, dimensions and qualities" in his pictures. And although he would imitate nature, he also went beyond it by selecting only those features which he believed to be beautiful. But even his ideas of beauty were based on his studies of nature. What the artist needed were the technical and imitative skills of a craftsman. Those were the sources of his gift or his genius.

In his attempt to interpret Arcimboldo's art in the context of Mannerism, Gustav René Hocke begins by showing the differences between this movement and the Renaissance. The Renaissance, says Hocke, brought about not only an interest in antiquity but also the birth of something completely new which he calls "non-naturalist abstraction". The forces of the late Middle Ages had come back to life again. A kind of "fantasy art" developed. "Psychological experiences and emotions were rated higher than exact correspondences with sensory perception". The art of idealized nature is seen as being in contrast with the work of art as the enactment of an idea.

According to Zuccari, as Hocke understands him, our mind first gives rise to a *concetto,* that is to say, the concept of a picture or the picture of a concept. A *concetto* is not abstract. It is a pre-existent mental image, a *disegno interno,* or internal sketch. In the next step, the *disegno esterno,* we put this into practice. "Zuccari distinguishes three forms of *disegno esterno,* i. e. of an applied *concetto:* (1) the *disegno naturale,* in which art imitates nature; (2) the *disegno artificiale,* where the mind uses nature to create its own artistic picture; (3) and the *disegno fantastico-artificiale:* the origin of all 'oddities', surprising turns, *capricci* (literally, the leaps and bounds of a goat), 'inventions', 'fantasies' and *ghiribizzi,* i. e. the extraordinary."

An artistic idea is the manifestation of the divine in the artist's soul. "God creates natural things, the artist artificial things. The human imagination – just as in a dream and also like God – forms new shapes and new things." A work of art is the result of an artist's idea.

For Hocke there can be no doubt that Arcimboldo, too, used to have *concetti,* that is to say, images or concepts in the sense of *disegno-metaforico-fantastico.* In other words, Arcimboldo painted metaphorical fantasy pictures. He even regards Arcimboldo's works as absolutely typical of this kind of art. However, the artist did not paint "mannerist emblems" but simple "mannerist allegories".

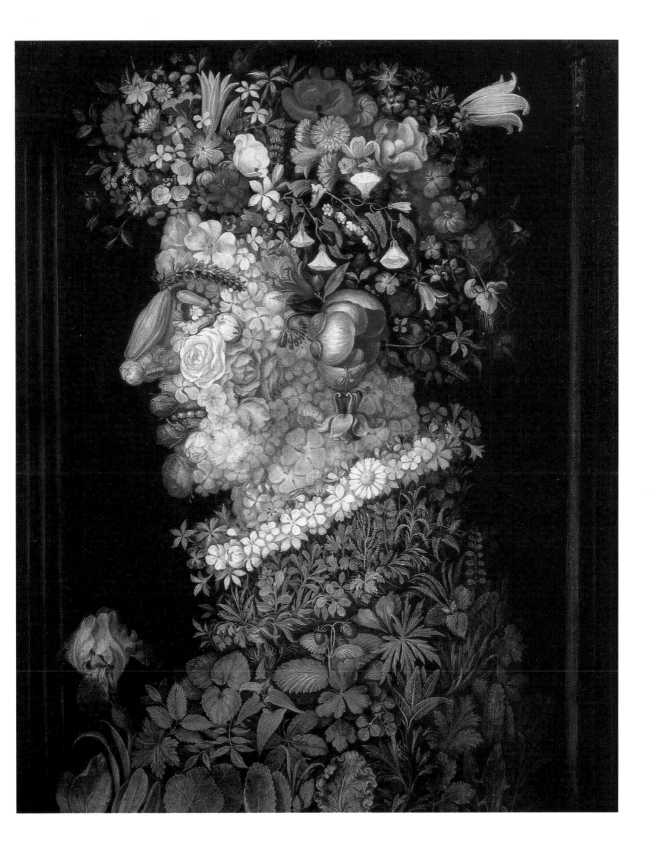

Summer, undated
Oil on wood, 84 × 57 cm
Bayerische Staatsgemäldesammlungen,
Munich

Legrand and Sluys' book *Arcimboldo et les Arcimboldesques* begins with an essay on the painter. In it the authors praise Arcimboldo's ability as an artist, his expertise in harmonizing the colours and his confident use of the brush. However, they find his *têtes composées* rather difficult to understand. They are impressed by the extraordinary magic of those pictures, but they find his "biting sense of humour" almost unbearable. They rather feel that Arcimboldo has mocked and scorned the idea of the human face as a "mirror of the soul". They accuse him of depriving man of his human nature, and objects of their meanings.

As Arcimboldo never left anything written about his pictures or himself, the authors try to find access to him through his contemporaries. This led them to think of him as a typical representative of Mannerism, which – they assume – must have been the reason why he sank into oblivion so rapidly after his death. It was not until Surrealism that the shock effect of these *bizarreries plastiques* was re-discovered.

Arcimboldo was highly educated, well-read and familiar with the philosophical ideas of the ancient Greeks. This was particularly apparent in the processions which he organized for the Hapsburgs, such as the one in Vienna in 1571, of which we still have records. At that time, people were becoming more and more interested in Platonism, particularly in Italy, and the Platonic Academy of Florence was founded. This must have made a considerable impression on Arcimboldo and aroused or re-inforced his interest in Plato. It is quite likely, in fact, that he was familiar with Plato's *Timaeus* and his ideas about the origin of the world, and that these philosophical writings influenced his *têtes composées*. This can be substantiated by a number of passages from *Timaeus*. Plato's basic idea is that of "an eternal god" who created the world from chaos: the heavens, the earth, the planets and the lesser gods. He also maintains that everything was created from four basic elements: fire, water, air and earth.

"As we said at the beginning, these things were in disorder till God introduced measurable relations, internal and external, among them, to the degree and extent that they were capable of proportion and measurement. For at first they stood in no such relations, except by chance, nor was there anything that deserved the names – fire, water, and the rest – which we now use. But he reduced them to order, and then put together this universe out of them, a single living creature containing in itself all other living things mortal and immortal. He made the divine with his own hands, but he ordered his own children to make the generation of mortals." These young gods followed their father's instructions, "and in imitation of their own maker borrowed from the world portions of fire and earth, water and air – loans to be eventually repaid – and welded together what they had

This depiction of **Summer** is the most unusual one among the four paintings shown in this book. A close study of the individual elements may reveal that in a number of places the paint was applied rather more spontaneously.

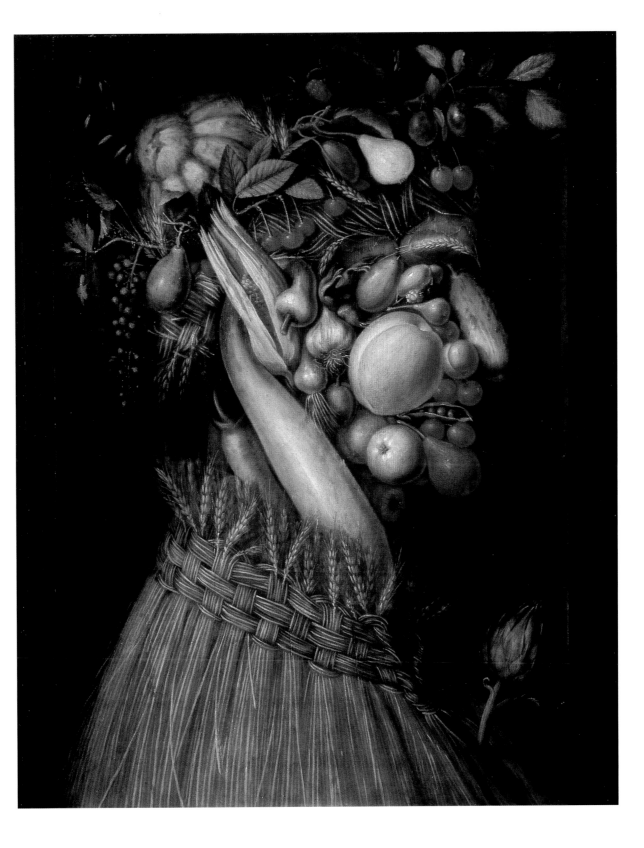

borrowed; the bonding they used was not indissoluble, like that by which they were themselves held together, but consisted of a multitude of rivets too small to be seen, which held the part of each individual body together in a unity. And into this body, subject to the flow of growth and decay, they fastened the orbits of the immortal soul."

The following passage shows that animals were made from the same substance. "For those who framed us knew that later on women and other animals would be produced from men, and that many creatures would need claws and hoofs for different purposes; so they provided the rudiments of them in men at their first creation, and for this reason and by these means caused skin, hair and nails to grow at the extremities of their limbs."

Just as the world, the gods and mankind consist of the same substance, plants and animals also consist of fire, water, air and earth. "The parts and limbs of the mortal creature were thus brought together into a whole which must of necessity live its life exposed to fire and air, be worn away and wasted by them, and finally perish. And to support it the gods devised and brought into being a substance akin to it, but with different form and senses, another kind of living thing, trees, plants and seeds. These we have today schooled and domesticated to our purposes by agriculture, but at first there were only the wild varieties, which are the older of the two. Everything that has life has every right to be called a living thing."

It seems obvious that, like Plato, Arcimboldo saw the entire universe, mankind, animals and plants, as a unit, and that he painted his pictures with this unity in mind.

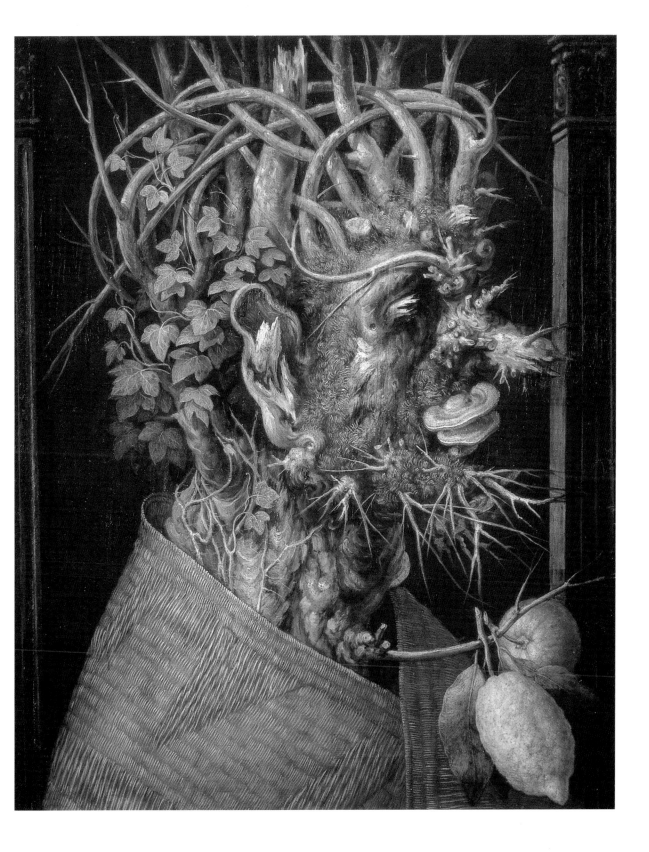

Arcimboldo as a Scientist

When we think of Leonardo da Vinci, we admire him not only for his art, but also his many scientific activities. Arcimboldo was in fact very similar. Not only was he valued as a painter, art connoisseur and organizer of tournaments, but also as a first-class scientist and engineer.

PAGE 63:

The Birth of St. Catherine
Stained glass window, 116 × 67 cm
Milan Cathedral, pane no. 6 in the 14th
window of the southern apse.
To a design by Arcimboldo (ca. 1551),
executed in Cologne, 1566.

To show that Arcimboldo also used to
work within the stylistic conventions of
his time, we have included two pictures
of stained glass windows at Milan
Cathedral. It is not known how many
designs were made by Arcimboldo. Even
the ones that were actually used cannot
all be identified with absolute certainty,
because Arcimboldo was not the only
artist working for Milan Cathedral.
His design for **The Birth of St. Catherine**
forms part of a cycle based on the legend
of St. Catherine of Alexandria, who was
martyred for refusing to sacrifice to the
statues of Zeus and Aphrodite.
This design, which was executed by the
Cologne master Konrad de Mochis,
shows no indication of Arcimboldo's
later development. Nevertheless, he
received a lot of praise for these pictures
from his contemporaries, just as he did
for his other works.

OPPOSITE PAGE:

**St. Catherine Talks to the Emperor about
the True Faith**
Stained glass window, 116 × 67 cm
Milan Cathedral, pane no. 57 of the 14th
window in the southern apse.
To a design by Arcimboldo (ca. 1551),
executed in Cologne, 1566.

This second example of Arcimboldo's
traditional style has been taken from the
same legend. It shows St. Catherine
talking to the Emperor and his scholars.
When the Emperor had heard of
Catherine's refusal to sacrifice to the
gods, he called upon fifty learned men to
make her change her views. As a result,
however, they were all defeated by the
witness of this young follower of the Lord
and became Christians themselves. Like
Catherine, they were all put to death.

PAGES 66 AND 67:

Eve and the Apple, with Counterpart,
1578
Oil on canvas, each 43 × 35.5 cm
Private collection, Basle

His friends thought of him as a man of the "sharpest
intelligence" and someone who was "extremely well-read". His
contemporaries used to praise his resourcefulness as an
architect and a builder of fortresses as well as his ingenuity
and inventiveness. For example, he was said to have
developed a method of crossing a river quickly without a
bridge or a ferry.

Through Don Gregorio Comanini, we know about the
scientific side of Arcimboldo's work. In Benno Geiger's book
we find a discussion of Arcimboldo by Lionello Levi, a music
critic, who discusses what he calls "this somewhat nebulous
account" by Comanini.

Lionello Levi shows that Arcimboldo took as his starting
point the "pythagorean harmonic proportions of tones and
semitones" which he subsequently translated into their
corresponding colour values, using both his artistic "instinct"
and a scientific method.

And indeed Arcimboldo must have been quite successful
in his endeavour, because, according to Comanini,
Arcimboldo once gave instructions to Mauro Cremonese,
Rudolph II's court musician: having painted a number of
chords on paper, he asked the musician to locate them on his
harpsichord, which he did with success. "This extremely
inventive painter," wrote Comanini, "knew not only how to
find the relevant semitones, both small and large, in his
colours, but also how to divide a tone into two equal parts;
very gently and softly he would gradually turn white into
black, increasing the amount of blackness, in the same way
that one would start with a deep, heavy note and then ascend
to the high and finally the very high ones."

In this way, step by step, starting from the purest white
and adding more and more black, he managed to render an
octave in twelve semitones, with the colours ranging from a
"deep" white to a "high" black. He then did the same for a
range of two octaves.

"For just as he would gradually darken the colour white
and use black for indicating heights, he did the same with
yellow and all the other colours, using white for the lowest
notes that one could sing, then green and blue for the middle
ones, then brightly glowing colours and dark brown for the
highest notes: this was possible because one colour really
merges into another and follows it like a shadow. White is
followed by yellow, yellow by green, and green by blue, blue
by purple, and purple by a glowing red; just as tenor follows
bass, alto follows tenor and canto follows alto."

This account of Gregorio Comanini's probably only
describes the beginning of Arcimboldo's research. As the artist
himself did not leave any notes, we can only speculate that he
intended to extend the system along the lines of a "theory of
perception".

The Passing of the Virgin
Mural tapestry, 423 × 470 cm
Como Cathedral
Inscription at the top: The Wool
Weavers' Guild of Como
Inscription in the lower left-hand corner:
made in Ferrara 1562

It is unlikely, however, that Giuseppe Arcimboldo wanted to abolish the system of musical notation, which had already been fixed at the time, and substitute his own colour scale for it.

In fact Gregorio Comanini probably gives us the best idea of his aims: "So you can see that the art of music and the art of painting walk along the same path and follow the same laws of creation."

This mural tapestry, which Arcimboldo had designed for Como Cathedral, is a further example of his art before he moved to Prague. There are eight designs with themes from the Old and New Testament, all of which are almost certainly by Arcimboldo.
Surrounded by a fantastic landscape and the twelve apostles, the Virgin Mary is lying on her death-bed.
Geiger maintains that, although the general approach is traditional in these designs, they already contain elements of the painter's later development. Geiger points out that there is a similarity between the elaborate decorations that form the frame and Arcimboldo's later pictures.

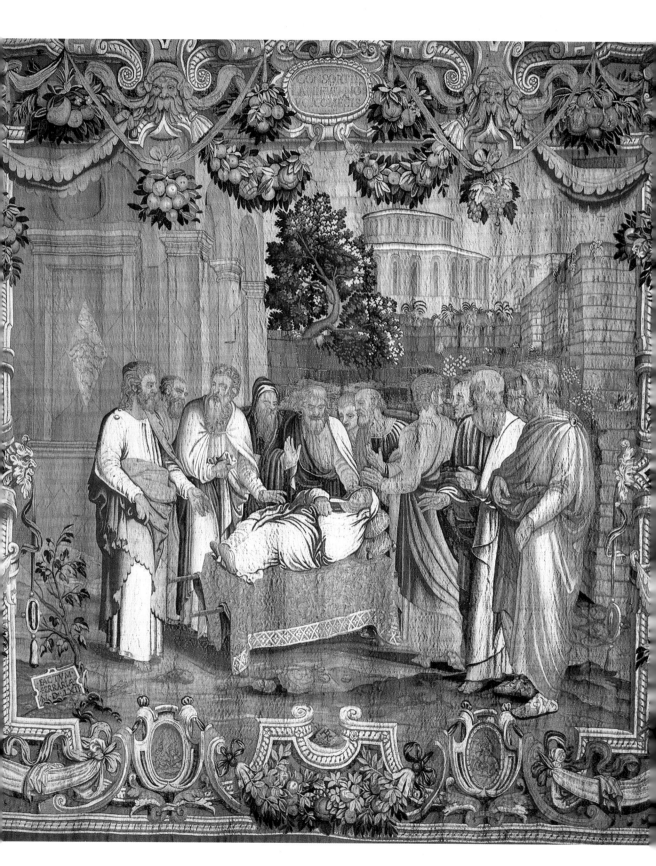

In 1585 Arcimboldo presented Emperor Rudolph II with a folio of red morocco leather containing about 150 blue pen-and-ink drawings. This folio is now in the Uffizi in Florence and bears the following Latin inscription:

PAGE 70:

Design of a sledge
Blue pen-and-wash drawing, 19 × 23 cm,
Inv. No. 3278 B

PAGE 71:

Design of a custome for Cerberus,
probably from Diana's group in the
festive procession in Vienna, 1571.
Blue pen-and-wash drawing, 29 × 19 cm,
Inv. No. 3224

OPPOSITE PAGE ABOVE:

Design of a dragon-like costume for a horse
Blue pen-and-wash drawing, 25 × 19 cm,
Inv. No. 3224

OPPOSITE PAGE BELOW:

Drawing of an elephant
Ink drawing, 24 × 18.7 cm,
Inv. No. 3225
The procession of 1570 was the first
occasion in Europe when an elephant
was shown.

Dedicated to
THE INVINCIBLE EMPEROR OF THE ROMANS
HIS EVERLASTING
AND MOST BENEVOLENT SOVEREIGN AND
MAJESTY RUDOLPH II
by Giuseppe Arcimboldo of Milan:
sundry different ideas designed by his own hand
for the furnishing of tournaments.
IN THE YEAR OF OUR LORD 1585.

These sketches are drawings which Arcimboldo made specially for the processions and balls of the Hapsburg emperors. Most of them were designed for the wedding celebrations of Archduke Charles of Styria and Mary of Bavaria in 1571, some of them for several other feasts, and the remaining ones cannot be dated. The sketches were made in the traditional style, with their plasticity heightened by the use of blue prepared paper. The costumes and hairstyles were modelled on contemporary designs. We have to bear in mind, of course, that the sketches were meant to serve as instructions for the tailors and seamsters who made the costumes, and it is therefore more appropriate to look at them from a historical point of view, rather than an artistic one. The diversity of these drawings gives us a good idea of Arcimboldo's wealth of imagination.

The festive processions which Arcimboldo helped to organize as a designer served to glorify the Emperor, and this was also the function of the artist's pictures. According to DaCosta Kaufmann, the political function and the sumptuous style of such festivities have been well documented by Giovanni Battista Fonteo's poems and descriptions. Archduke Charles' wedding festivities of 1571 are described in a panegyric by Fonteo, who gives a very graphic and detailed account of the feast. The following description is taken from Andreas Beyer, *Arcimboldo, Figurinen,* where a summary of the panegyric can be found.

At the beginning of the ceremonies there was always what was known as a *circle race,* which took place in an open field outside the city walls. An artificial hill was erected there, as well as two pyramids to mark the tilting-ground. Juno, the patron goddess of weddings, was the first to enter the scene, standing in a carriage pulled by peacocks. She was accompanied by the three kings of the continents Africa, Asia and America. All four characters were played by members of the Imperial family. During the games that followed the procession they acted as *mantenitori,* i.e. as observers and referees. Juno was followed by Iris, who descended from a cloud and gave the call to begin the contest. Other goddesses then entered the scene. There was Europa riding a horse disguised as a bull, followed by the Sirens and the Seven Liberal Arts. In Fonteo's poem these *artes liberales* are

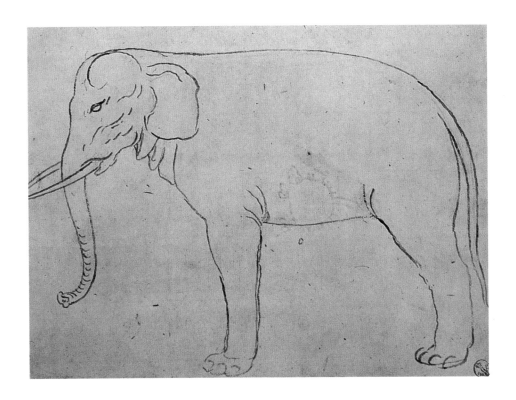

described as the children of Mercury, played by seven
noblemen, the Emperor's chamberlains. Each of the arts was
accompanied by two of its most typical representatives.
Rhetorick, for example, appeared together with Demosthenes
and Cicero. The Florence folio included all seven designs. At
the top of each sketch there is a description of the festive
garments as well the names of the two accompanying
representatives of the discipline.

Then there was Diana, accompanied by a unicorn and a
group of attendants and followed by her entourage of
noblemen disguised as wild animals. In her train were a group
of wild men with horn and amazons carrying bows, arrows
and spears.

Next came Neptune, surrounded by men who were
disguised as the kinds of fish that could be found in the waters
around Europe.

Neptune's group was followed by that of Pallas Athene,
who was standing on the platform of a carriage, side by side

with an owl which had four placards fastened to it. These placards bore the names of four vices. There were also the Cardinal Virtues, accompanied by a figure which personified Victory. Justice, Fortitude and Temperance were always played by members of the Imperial family and nobility. Together with Venus, who was surrounded by *Amori,* there was also an allegorical figure symbolizing Greed. In the records of the festivities it is mentioned that Bacchus was played by a man in a tub and that he and his entourage caused a lot of hilarity among the spectators. Bacchus was followed by four noblemen symbolizing the four elements. These appeared together with four men representing the four winds, and four gods bearing the four metals that belonged to them; and there were also four European rivers and four European nations disguised as four different ages of mankind. The four nations were accompanied by the four seasons as well as some horn players representing the east wind and Mars holding a piece of iron. After an allegorical figure representing Spring

ABOVE LEFT:

Design of a costume for "Rhetorick"
in the festive procession in Vienna, 1571.
Blue pen-and-wash drawing, 30 × 20 cm, Inv. No. 3152
Inscription at the top: "Rhetorick, led by Cicero the Roman and Demosthenes the Athenean. Red garment."

ABOVE RIGHT:

Design of a costume for "Astrology"
in the festive procession in Vienna, 1571.
Blue pen-and-wash drawing, 30 × 20 cm, Inv. No. 3156
Inscription at the top: "Astrology, led by Ptolemy the Alexandrian and Julius Hyginus the Roman. White garment, the edges in red with gold stars."

there was another carriage with a platform. Representing the river Po, it characterized the whole group which preceded it as the Italian contingent.

The Spanish group was led by Zephyrus and two other west winds. The figure of Fire was followed by the Sun carrying the Spanish element, gold. Rudolph II, who was the heir to the throne and had been brought up at the Spanish court, was the personification of the Sun in this group. The river Iberus concluded the Spanish group.

The south wind which, together with the south-west and south-east winds, led the Gaulish group was represented by horn players. The Earth was followed by Jupiter bearing a gift from Gaul: tin. Before the river Rhône concluded this group, there were some more noblemen, including one disguised as a French knight and symbolizing Autumn.

The last group was the German one, led by the north winds. The goddess Luna, who was bearing the German metal, silver, was preceded by a personification of the element water. Maximilian II, dressed as Winter, was the leader of the German group, which was concluded by the Danube.

The first day ended with a dinner and a ball, to which all the guests came dressed in magnificent costumes. On the second day the allegorical fun was concluded with a further procession.

Chronology

1527 Birth of Giuseppe Arcimboldo in Milan. His mother's name is Chiara Parisi. His father is Biagio Arcimboldo, a painter. Birth of Maximilian II.

1549 24 December: first mention of Arcimboldo's name in the register of the workshop at Milan Cathedral, where he is working as one of his father's assistants.

1552 Birth of Rudolph II, son of Maximilian II.

1558 Arcimboldo finishes his work at Milan Cathedral. Designs for a gobelin tapestry for Como Cathedral.

1562 Arcimboldo moves to Vienna, where he is appointed to the court as a portrait artist and copyist. Maximilian is crowned King of Bohemia and of the Roman Empire.

1563 Arcimboldo paints his first series of Seasons.

1564 Maximilian becomes Holy Roman Emperor.

1565 Arcimboldo is named in the Imperial court register as the court taker of likenesses.

1566 Arcimboldo paints *The Lawyer* and begins his series of *The Four Elements*. Travels to Italy.

1568 Giambattista Fonteo becomes Arcimboldo's assistant.

1569 Maximilian is given the *Seasons* and *Four Elements* at New Year. Arcimboldo and Fonteo write a poem to accompany the paintings.

1570 Maximilian II's daughter Elizabeth marries Charles IX of France and a grand festival is put on in Prague. Arcimboldo is one of the organizers and participants.

1571 Archduke Charles of Austria marries Maria of Bavaria in Vienna, and Arcimboldo, together with Fonteo and Jacopo Strada, takes charge of the organization.

1572 Copies of the *Seasons*.

1573 Arcimboldo paints the third and fourth versions of the *Seasons,* which Maximilian II has ordered as a gift of homage to the Prince Elector of Saxony.

1575 Rudolph II is crowned King of Bohemia in Prague, and shortly afterwards King of the Roman Empire in Regensburg.

1576 Death of Emperor Maximilian II, Rudolph II becomes Emperor.

1580 Rudolph II ennobles the Arcimboldo family.

1584 G. Lomazzo's commentary on Arcimboldo, the first on the artist, is published in Lomazzo's *Trattato dell' Antichitá della Pittura.*

1585 Arcimboldo makes Rudolph II a present of 148 designs for costumes, headgear and decorative wear.

1587 Arcimboldo leaves Prague and goes to Milan. The Emperor gives the artist 1550 guilders in recognition of his services.

1589 Arcimboldo sends his *Flora* from Milan to Prague. It is accompanied by a poem by Gregorio Comanini.

1591 Comanini publishes *Il Figino* in Mantua. Arcimboldo's portrait of Rudolph II as *Vertumnus* is sent to Prague with a poem by Comanini.

1592 Paolo Morigia's *Historia dell' Antichitá di Milano* is published in Venice.

1593 Giuseppe Arcimboldo dies in Milan.

Bibliography

Alfons, Sven: Giuseppe Arcimboldo. Malmö 1957

Barthes, Roland: Arcimboldo. Assisted by Achille Bonito
 Oliva, Corinna Ferrari and Francesco Porzi. Parma 1978

Beyer, Andreas: Giuseppe Arcimboldo, Figurinen. Frankfurt o. M. 1983

Casati, Carlo: Giuseppe Arcimboldo pittore milanese. In:
 Archivio storico Lombardo, XII (1985)

DaCosta Kaufmann, Thomas: Variations on the Imperial
 Theme in the Age of Maximilian II and Rudolph II.
 New York 1978

Evans, R. J. W.: Rudolph II and his World. A Study in
 Intellectual History 1576–1612. Oxford 1973

Geiger, Benno: Die skurrilen Gemälde des Giuseppe
 Arcimboldo, Wiesbaden 1960

Hauser, Arnold: Der Manierismus. Munich 1964

Hocke, Gustav René: Die Welt als Labyrinth. Reinbek 1957

Legrand, Francine-Claire and Felix Sluys: Arcimboldo et les
 Arcimboldesques. Aalter 1955

Pieyre de Mandiargues, André: Das Wunder Arcimboldo.
 Cologne 1978

Plato, Timaeus and Critias, translated by M. D. P. Lee.
 London 1965

Preiss, Pavel: Giuseppe Arcimboldo. Prague 1967

Stilleben in Europa. Exhibition catalogue, Landschaftsverband
 Westfalen-Lippe. Münster 1979

Wescher, Paul: The "Idea" in Giuseppe Arcimboldo's Art. In:
 Magazine of Art. Washington Jan. 1950

Würtemberger, Franzsepp: Der Manierismus. Vienna 1962

The author and the publishers would like to thank museums, collectors,
photographers and archives for their kind permission to reproduce the
illustrations in this book. Artothek, Planegg/Germany;
Peter Heman, Basle; Foto Linster, Telfs/Germany; Meyer KG, Vienna;
Bildarchiv Benedikt Taschen Verlag, Cologne; Walther & Walther Verlag,
Alling/Germany.